Marilyn

©. ANDRE DE Dienes

2006 TASCHEN DIARY

www.taschen.com

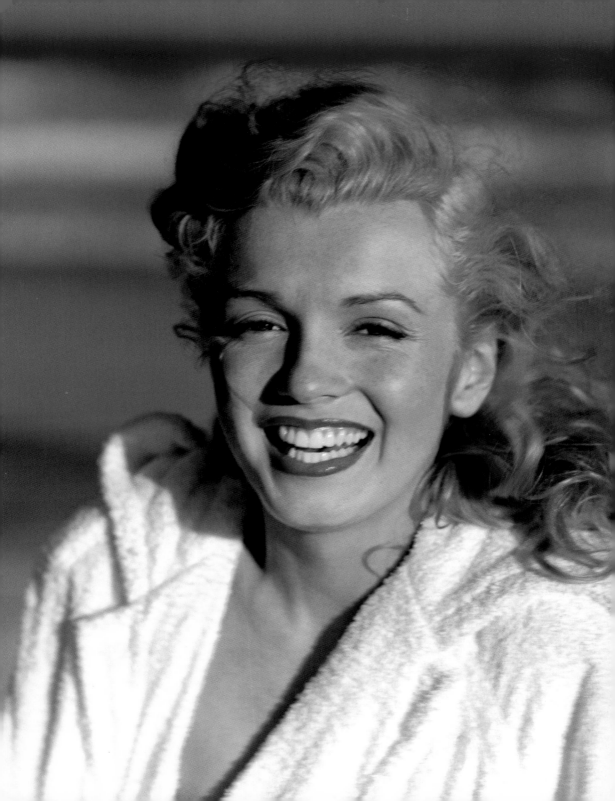

09–12.2005

SEPTEMBER	OCTOBER	NOVEMBER	DECEMBER
1 Th	1 Sa	1 Tu	1 Th ●
2 Fr	2 Su	2 We ●	2 Fr
3 Sa ●	**WEEK 40**	3 Th	3 Sa
4 Su	3 Mo ●	4 Fr	4 Su
WEEK 36	4 Tu	5 Sa	**WEEK 49**
5 Mo	5 We	6 Su	5 Mo
6 Tu	6 Th	**WEEK 45**	6 Tu
7 We	7 Fr	7 Mo	7 We
8 Th	8 Sa	8 Tu	8 Th ◐
9 Fr	9 Su	9 We ◐	9 Fr
10 Sa	**WEEK 41**	10 Th	10 Sa
11 Su ◐	10 Mo ◐	11 Fr	11 Su
WEEK 37	11 Tu	12 Sa	**WEEK 50**
12 Mo	12 We	13 Su	12 Mo
13 Tu	13 Th	**WEEK 46**	13 Tu
14 We	14 Fr	14 Mo	14 We
15 Th	15 Sa	15 Tu	15 Th ○
16 Fr	16 Su	16 We ○	16 Fr
17 Sa	**WEEK 42**	17 Th	17 Sa
18 Su ○	17 Mo ○	18 Fr	18 Su
WEEK 38	18 Tu	19 Sa	**WEEK 51**
19 Mo	19 We	20 Su	19 Mo
20 Tu	20 Th	**WEEK 47**	20 Tu
21 We	21 Fr	21 Mo	21 We
22 Th	22 Sa	22 Tu	22 Th
23 Fr	23 Su	23 We ◑	23 Fr ◑
24 Sa	**WEEK 43**	24 Th	24 Sa
25 Su ◑	24 Mo	25 Fr	25 Su
WEEK 39	25 Tu ◑	26 Sa	**WEEK 52**
26 Mo	26 We	27 Su	26 Mo
27 Tu	27 Th	**WEEK 48**	27 Tu
28 We	28 Fr	28 Mo	28 We
29 Th	29 Sa	29 Tu	29 Th
30 Fr	30 Su	30 We	30 Fr
	WEEK 44		31 Sa ●
	31 Mo		

01–04.2006

JANUARY

1 Su

WEEK 1

2 Mo
3 Tu
4 We
5 Th
6 Fr ◐
7 Sa
8 Su

WEEK 2

9 Mo
10 Tu
11 We
12 Th
13 Fr
14 Sa ○
15 Su

WEEK 3

16 Mo
17 Tu
18 We
19 Th
20 Fr
21 Sa
22 Su ◑

WEEK 4

23 Mo
24 Tu
25 We
26 Th
27 Fr
28 Sa
29 Su ●

WEEK 5

30 Mo
31 Tu

FEBRUARY

1 We
2 Th
3 Fr
4 Sa
5 Su ◐

WEEK 6

6 Mo
7 Tu
8 We
9 Th
10 Fr
11 Sa
12 Su

WEEK 7

13 Mo ○
14 Tu
15 We
16 Th
17 Fr
18 Sa
19 Su

WEEK 8

20 Mo
21 Tu ◑
22 We
23 Th ○
24 Fr
25 Sa
26 Su

WEEK 9

27 Mo
28 Tu ●

MARCH

1 We
2 Th
3 Fr
4 Sa
5 Su

WEEK 10

6 Mo ◐
7 Tu
8 We
9 Th
10 Fr
11 Sa
12 Su

WEEK 11

13 Mo
14 Tu ○
15 We
16 Th
17 Fr
18 Sa
19 Su

WEEK 12

20 Mo
21 Tu
22 We ◑
23 Th
24 Fr
25 Sa
26 Su

WEEK 13

27 Mo
28 Tu
29 We ●
30 Th
31 Fr

APRIL

1 Sa
2 Su

WEEK 14

3 Mo
4 Tu
5 We ◐
6 Th
7 Fr
8 Sa
9 Su

WEEK 15

10 Mo
11 Tu
12 We
13 Th ○
14 Fr
15 Sa
16 Su

WEEK 16

17 Mo
18 Tu
19 We
20 Th
21 Fr ◑
22 Sa
23 Su

WEEK 17

24 Mo
25 Tu
26 We
27 Th ●
28 Fr
29 Sa
30 Su

05–08.2006

MAY

WEEK 18

1 Mo
2 Tu
3 We
4 Th
5 Fr ◐
6 Sa
7 Su

WEEK 19

8 Mo
9 Tu
10 We
11 Th
12 Fr
13 Sa ○
14 Su

WEEK 20

15 Mo
16 Tu
17 We
18 Th
19 Fr
20 Sa ◑
21 Su

WEEK 21

22 Mo ○
23 Tu
24 We
25 Th
26 Fr
27 Sa ●
28 Su

WEEK 22

29 Mo
30 Tu
31 We

JUNE

1 Th
2 Fr
3 Sa ◐
4 Su

WEEK 23

5 Mo
6 Tu
7 We
8 Th
9 Fr
10 Sa
11 Su ○

WEEK 24

12 Mo
13 Tu
14 We
15 Th
16 Fr
17 Sa
18 Su ◑

WEEK 25

19 Mo
20 Tu
21 We
22 Th
23 Fr
24 Sa
25 Su ●

WEEK 26

26 Mo
27 Tu
28 We
29 Th
30 Fr

JULY

1 Sa
2 Su

WEEK 27

3 Mo ◐
4 Tu
5 We
6 Th
7 Fr
8 Sa
9 Su

WEEK 28

10 Mo
11 Tu ○
12 We
13 Th
14 Fr
15 Sa
16 Su

WEEK 29

17 Mo ◑
18 Tu
19 We
20 Th
21 Fr
22 Sa
23 Su

WEEK 30

24 Mo
25 Tu ●
26 We
27 Th
28 Fr
29 Sa
30 Su

WEEK 31

31 Mo

AUGUST

1 Tu
2 We ◐
3 Th
4 Fr
5 Sa
6 Su

WEEK 32

7 Mo
8 Tu
9 We ○
10 Th
11 Fr
12 Sa
13 Su

WEEK 33

14 Mo
15 Tu
16 We ◑
17 Th
18 Fr
19 Sa
20 Su

WEEK 34

21 Mo
22 Tu
23 We ●
24 Th
25 Fr
26 Sa
27 Su

WEEK 35

28 Mo
29 Tu
30 We
31 Th ◐

09–12.2006

SEPTEMBER

1 Fr
2 Sa
3 Su
WEEK 36
4 Mo
5 Tu
6 We
7 Th ○
8 Fr
9 Sa
10 Su
WEEK 37
11 Mo
12 Tu
13 We
14 Th ◑
15 Fr
16 Sa
17 Su
WEEK 38
18 Mo
19 Tu
20 We
21 Th
22 Fr ●
23 Sa
24 Su
WEEK 39
25 Mo
26 Tu
27 We
28 Th
29 Fr
30 Sa ◐

OCTOBER

1 Su
WEEK 40
2 Mo
3 Tu
4 We
5 Th
6 Fr
7 Sa ○
8 Su
WEEK 41
9 Mo
10 Tu
11 We
12 Th
13 Fr
14 Sa ◑
15 Su
WEEK 42
16 Mo
17 Tu
18 We
19 Th
20 Fr
21 Sa
22 Su ●
WEEK 43
23 Mo
24 Tu
25 We
26 Th
27 Fr
28 Sa
29 Su ◐
WEEK 44
30 Mo
31 Tu

NOVEMBER

1 We
2 Th
3 Fr
4 Sa
5 Su ○
WEEK 45
6 Mo
7 Tu
8 We
9 Th
10 Fr
11 Sa
12 Su ◑
WEEK 46
13 Mo
14 Tu
15 We
16 Th
17 Fr
18 Sa
19 Su
WEEK 47
20 Mo ●
21 Tu
22 We
23 Th
24 Fr
25 Sa
26 Su
WEEK 48
27 Mo
28 Tu ◐
29 We
30 Th

DECEMBER

1 Fr
2 Sa
3 Su
WEEK 49
4 Mo
5 Tu ○
6 We
7 Th
8 Fr
9 Sa
10 Su
WEEK 50
11 Mo
12 Tu ◑
13 We
14 Th
15 Fr
16 Sa
17 Su
WEEK 51
18 Mo
19 Tu
20 We ●
21 Th
22 Fr
23 Sa
24 Su
WEEK 52
25 Mo
26 Tu
27 We ◐
28 Th
29 Fr
30 Sa
31 Su

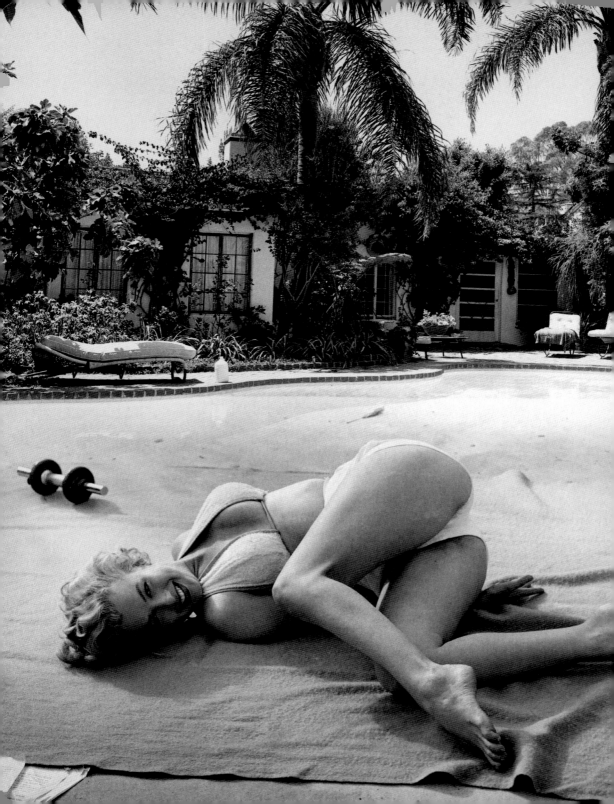

2006 JANUARY JANUAR JANVIER ENERO GENNAIO JANEIRO JANUARI 1月

DECEMBER 2005					
Monday	28	5	12	19	26
Tuesday	29	6	13	20	27
Wednesday	30	7	14	21	28
Thursday	1	8	15	22	29
Friday	2	9	16	23	30
Saturday	3	10	17	24	31
Sunday	4	11	18	25	1
Week	48	49	50	51	52

JANUARY 2006						
Monday	26	2	9	16	23	30
Tuesday	27	3	10	17	24	31
Wednesday	28	4	11	18	25	
Thursday	29	5	12	19	26	2
Friday	30	6	13	20	27	3
Saturday	31	7	14	21	28	4
Sunday	1	8	15	22	29	5
Week	52	1	2	3	4	5

FEBRUARY 2006					
Monday	30	6	13	20	27
Tuesday	31	7	14	21	28
Wednesday	1	8	15	22	1
Thursday	2	9	16	23	2
Friday	3	10	17	24	3
Saturday	4	11	18	25	4
Sunday	5	12	19	26	5
Week	5	6	7	8	9

26
Monday
Montag
Lundi
Lunes
Lunedì
Segunda-feira
Maandag
月曜日

(UK) (IRL) (CDN) (D) (A) (CH) (NL) (I)
Boxing Day | Saint Stephen's Day |
Lendemain de Noël | 2. Weihnachtstag |
Stefanstag | S. Etienne | 2e Kerstdag |
S. Stefano

27
Tuesday
Dienstag
Mardi
Martes
Martedì
Terça-feira
Dinsdag
火曜日

28
Wednesday
Mittwoch
Mercredi
Miércoles
Mercoledì
Quarta-feira
Woensdag
水曜日

29
Thursday
Donnerstag
Jeudi
Jueves
Giovedì
Quinta-feira
Donderdag
木曜日

30
Friday
Freitag
Vendredi
Viernes
Venerdì
Sexta-feira
Vrijdag
金曜日

● 31
Saturday
Samstag
Samedi
Sábado
Sabato
Sábado
Zaterdag
土曜日

1
Sunday
Sonntag
Dimanche
Domingo
Domenica
Domingo
Zondag
日曜日

New Year's Day | Jour de l'An |
Nouvel An | Neujahr | Capodanno |
Nieuwjaarsdag | Año Nuevo | Ano Novo

2006 JANUARY JANUAR JANVIER ENERO GENNAIO JANEIRO JANUARI 1月

DECEMBER 2005						JANUARY 2006						FEBRUARY 2006						
Monday	28	5	12	19	26	Monday	26	2	9	16	23	30	Monday	30	6	13	20	27
Tuesday	29	6	13	20	27	Tuesday	27	3	10	17	24	31	Tuesday	31	7	14	21	28
Wednesday	30	7	14	21	28	Wednesday	28	4	11	18	25	1	Wednesday	1	8	15	22	1
Thursday	1	8	15	22	29	Thursday	29	5	12	19	26	2	Thursday	2	9	16	23	2
Friday	2	9	16	23	30	Friday	30	6	13	20	27	3	Friday	3	10	17	24	3
Saturday	3	10	17	24	31	Saturday	31	7	14	21	28	4	Saturday	4	11	18	25	4
Sunday	4	11	18	25	1	Sunday	1	8	15	22	29	5	Sunday	5	12	19	26	5
Week	48	49	50	51	52	Week	52	1	2	3	4	5	Week	5	6	7	8	9

2
Monday
Montag
Lundi
Lunes
Lunedì
Segunda-feira
Maandag
月曜日

(USA) (UK) (IRL) (J)
Public Holiday

(IL) Hanukkah

3
Tuesday
Dienstag
Mardi
Martes
Martedì
Terça-feira
Dinsdag
火曜日

(UK) Public Holiday (Scotland only)

4
Wednesday
Mittwoch
Mercredi
Miércoles
Mercoledì
Quarta-feira
Woensdag
水曜日

5
Thursday
Donnerstag
Jeudi
Jueves
Giovedì
Quinta-feira
Donderdag
木曜日

6
Friday
Freitag
Vendredi
Viernes
Venerdì
Sexta-feira
Vrijdag
金曜日

(D) Heilige Drei Könige (teilweise)

(A) (E) (I) Heilige Drei Könige |
Reyes | Epifania

7
Saturday
Samstag
Samedi
Sábado
Sabato
Sábado
Zaterdag
土曜日

8
Sunday
Sonntag
Dimanche
Domingo
Domenica
Domingo
Zondag
日曜日

WEEK 1

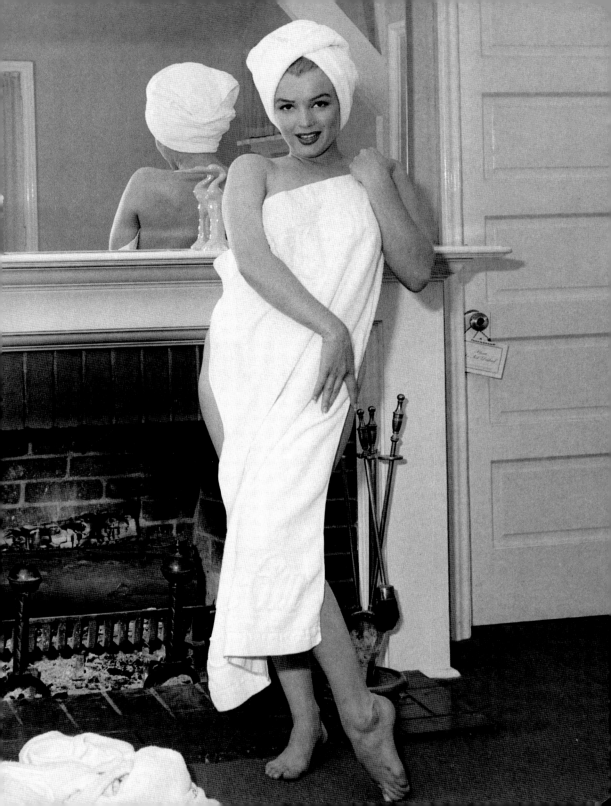

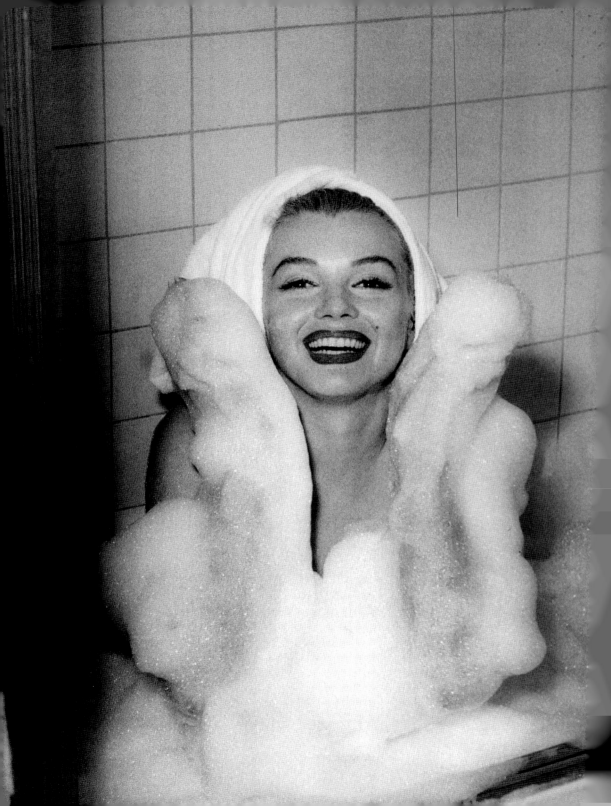

2006 JANUARY JANUAR JANVIER ENERO GENNAIO JANEIRO JANUARI 1月

DECEMBER 2005

Monday	28	5	12	19	26
Tuesday	29	6	13	20	27
Wednesday	30	7	14	21	28
Thursday	1	8	15	22	29
Friday	2	9	16	23	30
Saturday	3	10	17	24	31
Sunday	4	11	18	25	1
Week	48	49	50	51	52

JANUARY 2006

Monday	26	2	9	16	23	30
Tuesday	27	3	10	17	24	31
Wednesday	28	4	11	18	25	1
Thursday	29	5	12	19	26	2
Friday	30	6	13	20	27	3
Saturday	31	7	14	21	28	4
Sunday	1	8	15	22	29	5
Week	52	1	2	3	4	5

FEBRUARY 2006

Monday	30	6	13	20	27
Tuesday	31	7	14	21	28
Wednesday	1	8	15	22	1
Thursday	2	9	16	23	2
Friday	3	10	17	24	3
Saturday	4	11	18	25	4
Sunday	5	12	19	26	5
Week	5	6	7	8	9

9
Monday
Montag
Lundi
Lunes
Lunedì
Segunda-feira
Maandag
月曜日

10
Tuesday
Dienstag
Mardi
Martes
Martedì
Terça-feira
Dinsdag
火曜日

11
Wednesday
Mittwoch
Mercredi
Miércoles
Mercoledì
Quarta-feira
Woensdag
水曜日

12
Thursday
Donnerstag
Jeudi
Jueves
Giovedì
Quinta-feira
Donderdag
木曜日

13
Friday
Freitag
Vendredi
Viernes
Venerdì
Sexta-feira
Vrijdag
金曜日

14
Saturday
Samstag
Samedi
Sábado
Sabato
Sábado
Zaterdag
土曜日

15
Sunday
Sonntag
Dimanche
Domingo
Domenica
Domingo
Zondag
日曜日

2006 JANUARY JANUAR JANVIER ENERO GENNAIO JANEIRO JANUARI 1月

DECEMBER 2005					
Monday	28	5	12	19	26
Tuesday	29	6	13	20	27
Wednesday	30	7	14	21	28
Thursday	1	8	15	22	29
Friday	2	9	16	23	30
Saturday	3	10	17	24	31
Sunday	4	11	18	25	1
Week	48	49	50	51	52

JANUARY 2006						
Monday	26	2	9	16	23	30
Tuesday	27	3	10	17	24	31
Wednesday	28	4	11	18	25	1
Thursday	29	5	12	19	26	2
Friday	30	6	13	20	27	3
Saturday	31	7	14	21	28	4
Sunday	1	8	15	22	29	5
Week	52	1	2	3	4	5

FEBRUARY 2006					
Monday	30	6	13	20	27
Tuesday	31	7	14	21	28
Wednesday	1	8	15	22	1
Thursday	2	9	16	23	2
Friday	3	10	17	24	3
Saturday	4	11	18	25	4
Sunday	5	12	19	26	5
Week	5	6	7	8	9

16
Monday
Montag
Lundi
Lunes
Lunedì
Segunda-feira
Maandag
月曜日

(USA) Martin Luther King Day

17
Tuesday
Dienstag
Mardi
Martes
Martedì
Terça-feira
Dinsdag
火曜日

18
Wednesday
Mittwoch
Mercredi
Miércoles
Mercoledì
Quarta-feira
Woensdag
水曜日

19
Thursday
Donnerstag
Jeudi
Jueves
Giovedì
Quinta-feira
Donderdag
木曜日

20
Friday
Freitag
Vendredi
Viernes
Venerdì
Sexta-feira
Vrijdag
金曜日

21
Saturday
Samstag
Samedi
Sábado
Sabato
Sábado
Zaterdag
土曜日

22
Sunday
Sonntag
Dimanche
Domingo
Domenica
Domingo
Zondag
日曜日

WEEK 3

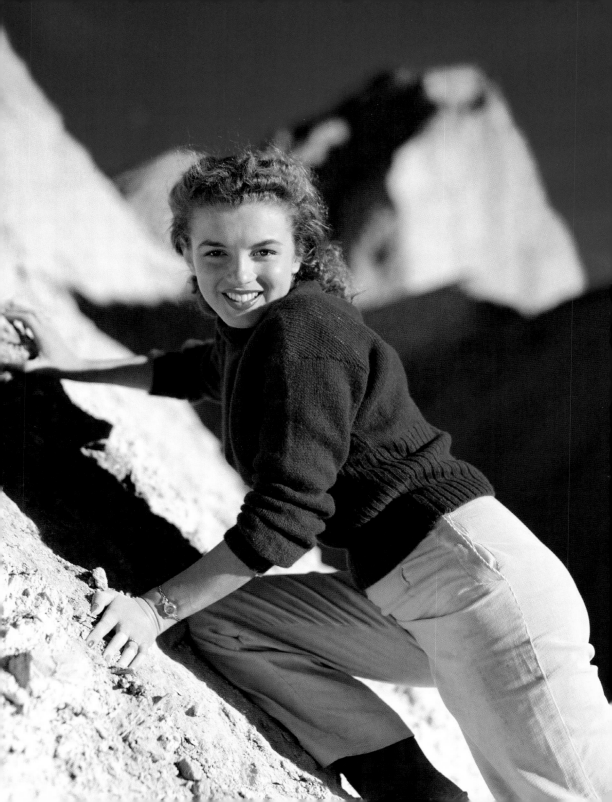

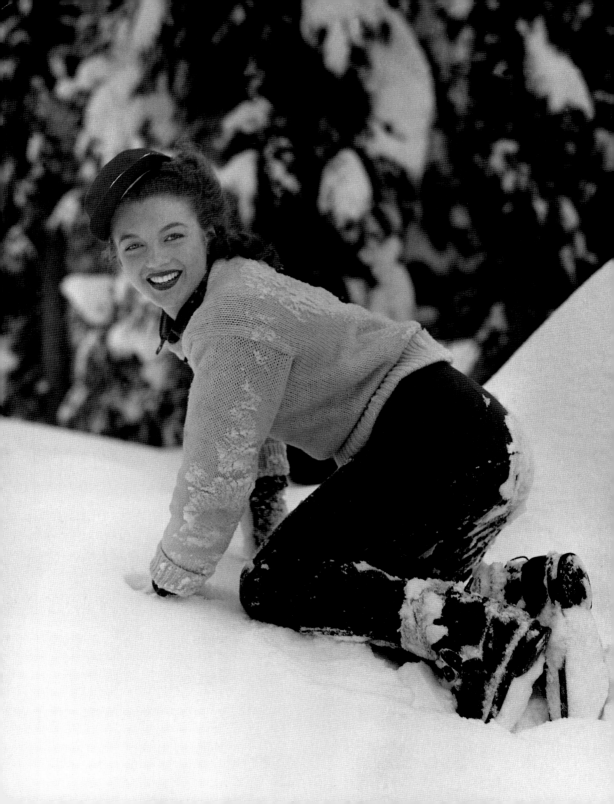

2006 JANUARY JANUAR JANVIER ENERO GENNAIO JANEIRO JANUARI 1月

DECEMBER 2005					
Monday	28	5	12	19	26
Tuesday	29	6	13	20	27
Wednesday	30	7	14	21	28
Thursday	1	8	15	22	29
Friday	2	9	16	23	30
Saturday	3	10	17	24	31
Sunday	4	11	18	25	1
Week	48	49	50	51	52

JANUARY 2006						
Monday	26	2	9	16	23	30
Tuesday	27	3	10	17	24	31
Wednesday	28	4	11	18	25	1
Thursday	29	5	12	19	26	2
Friday	30	6	13	20	27	3
Saturday	31	7	14	21	28	4
Sunday	1	8	15	22	29	5
Week	52	1	2	3	4	5

FEBRUARY 2006					
Monday	30	6	13	20	27
Tuesday	31	7	14	21	28
Wednesday	1	8	15	22	1
Thursday	2	9	16	23	2
Friday	3	10	17	24	3
Saturday	4	11	18	25	4
Sunday	5	12	19	26	5
Week	5	6	7	8	9

23
Monday
Montag
Lundi
Lunes
Lunedì
Segunda-feira
Maandag
月曜日

24
Tuesday
Dienstag
Mardi
Martes
Martedì
Terça-feira
Dinsdag
火曜日

25
Wednesday
Mittwoch
Mercredi
Miércoles
Mercoledì
Quarta-feira
Woensdag
水曜日

26
Thursday
Donnerstag
Jeudi
Jueves
Giovedì
Quinta-feira
Donderdag
木曜日

27
Friday
Freitag
Vendredi
Viernes
Venerdì
Sexta-feira
Vrijdag
金曜日

28
Saturday
Samstag
Samedi
Sábado
Sabato
Sábado
Zaterdag
土曜日

29
Sunday
Sonntag
Dimanche
Domingo
Domenica
Domingo
Zondag
日曜日

WEEK 4

2006 FEBRUARY

FEBRUAR FEVRIER FEBRERO FEBBRAIO FEVEREIRO FEBRUARI 2月

JANUARY 2006						
Monday	26	2	9	16	23	30
Tuesday	27	3	10	17	24	31
Wednesday	28	4	11	18	25	1
Thursday	29	5	12	19	26	2
Friday	30	6	13	20	27	3
Saturday	31	7	14	21	28	4
Sunday	1	8	15	22	29	5
Week	52	1	2	3	4	5

FEBRUARY 2006					
Monday	30	6	13	20	27
Tuesday	31	7	14	21	28
Wednesday	1	8	15	22	1
Thursday	2	9	16	23	2
Friday	3	10	17	24	3
Saturday	4	11	18	25	4
Sunday	5	12	19	26	5
Week	5	6	7	8	9

MARCH 2006					
Monday	27	6	13	20	27
Tuesday	28	7	14	21	28
Wednesday	1	8	15	22	29
Thursday	2	9	16	23	30
Friday	3	10	17	24	31
Saturday	4	11	18	25	1
Sunday	5	12	19	26	2
Week	9	10	11	12	13

30 Monday / Montag / Lundi / Lunes / Lunedì / Segunda-feira / Maandag / 月曜日

31 Tuesday / Dienstag / Mardi / Martes / Martedì / Terça-feira / Dinsdag / 火曜日

1 Wednesday / Mittwoch / Mercredi / Miércoles / Mercoledì / Quarta-feira / Woensdag / 水曜日

2 Thursday / Donnerstag / Jeudi / Jueves / Giovedì / Quinta-feira / Donderdag / 木曜日

3 Friday / Freitag / Vendredi / Viernes / Venerdì / Sexta-feira / Vrijdag / 金曜日

4 Saturday / Samstag / Samedi / Sábado / Sabato / Sábado / Zaterdag / 土曜日

5 Sunday / Sonntag / Dimanche / Domingo / Domenica / Domingo / Zondag / 日曜日

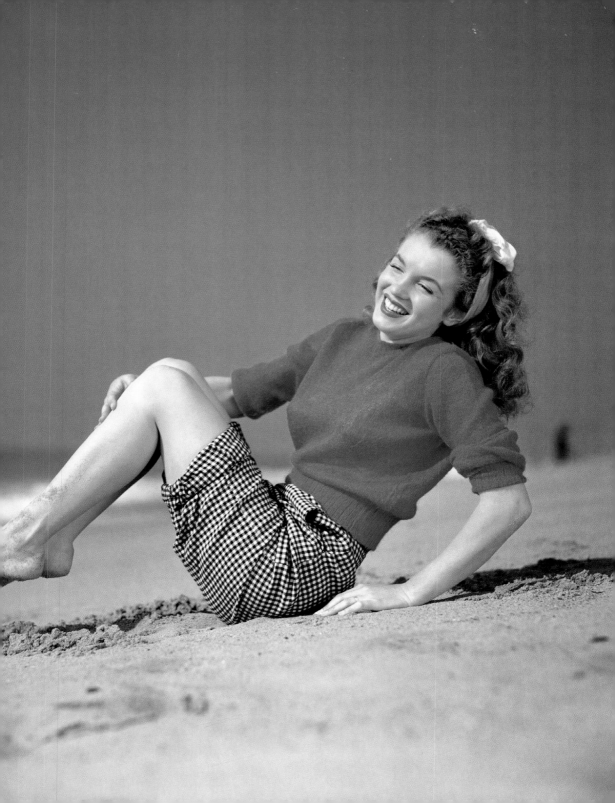

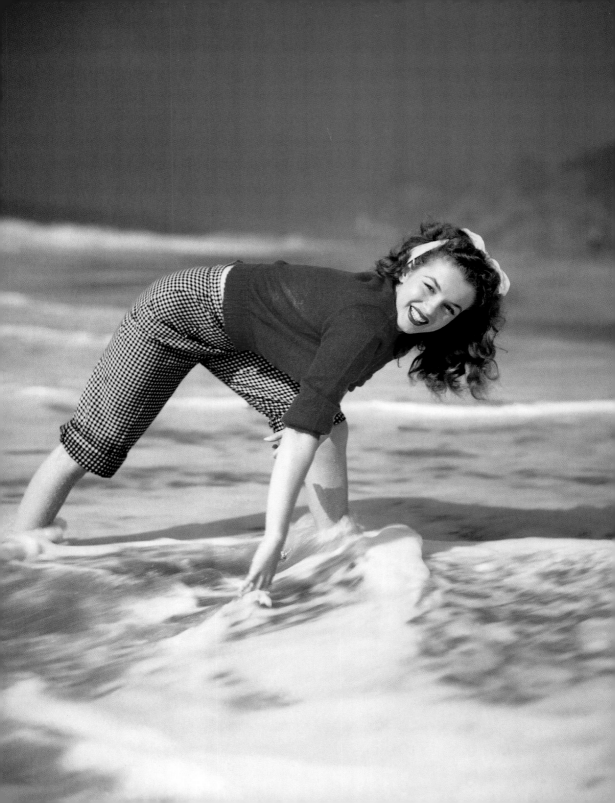

2006 FEBRUARY FEBRUAR FEVRIER FEBRERO FEBBRAIO FEVEREIRO FEBRUARI 2月

JANUARY 2006						
Monday	26	2	9	16	23	30
Tuesday	27	3	10	17	24	31
Wednesday	28	4	11	18	25	1
Thursday	29	5	12	19	26	2
Friday	30	6	13	20	27	3
Saturday	31	7	14	21	28	4
Sunday	1	8	15	22	29	5
Week	52	1	2	3	4	5

FEBRUARY 2006						
Monday	30	6	13	20	27	
Tuesday	31	7	14	21	28	
Wednesday	1	8	15	22	1	
Thursday	2	9	16	23	2	
Friday	3	10	17	24	3	
Saturday	4	11	18	25	4	
Sunday	5	12	19	26	5	
Week	5	6	7	8	9	

MARCH 2006						
Monday	27	6	13	20	27	
Tuesday	28	7	14	21	28	
Wednesday	1	8	15	22	29	
Thursday	2	9	16	23	30	
Friday	3	10	17	24	31	
Saturday	4	11	18	25	1	
Sunday	5	12	19	26	2	
Week	9	10	11	12	13	

6
Monday
Montag
Lundi
Lunes
Lunedì
Segunda-feira
Maandag
月曜日

7
Tuesday
Dienstag
Mardi
Martes
Martedì
Terça-feira
Dinsdag
火曜日

8
Wednesday
Mittwoch
Mercredi
Miércoles
Mercoledì
Quarta-feira
Woensdag
水曜日

9
Thursday
Donnerstag
Jeudi
Jueves
Giovedì
Quinta-feira
Donderdag
木曜日

10
Friday
Freitag
Vendredi
Viernes
Venerdì
Sexta-feira
Vrijdag
金曜日

11
Saturday
Samstag
Samedi
Sábado
Sabato
Sábado
Zaterdag
土曜日

Ⓙ Commemoration of the Founding
of the Nation

12
Sunday
Sonntag
Dimanche
Domingo
Domenica
Domingo
Zondag
日曜日

WEEK 6

2006 FEBRUARY
FEBRUAR FEVRIER FEBRERO FEBBRAIO FEVEREIRO FEBRUARI 2月

JANUARY 2006						
Monday	26	2	9	16	23	30
Tuesday	27	3	10	17	24	31
Wednesday	28	4	11	18	25	1
Thursday	29	5	12	19	26	2
Friday	30	6	13	20	27	3
Saturday	31	7	14	21	28	4
Sunday	1	8	15	22	29	5
Week	52	1	2	3	4	5

FEBRUARY 2006					
Monday	30	6	13	20	27
Tuesday	31	7	14	21	28
Wednesday	1	8	15	22	1
Thursday	2	9	16	23	2
Friday	3	10	17	24	3
Saturday	4	11	18	25	4
Sunday	5	12	19	26	5
Week	5	6	7	8	9

MARCH 2006					
Monday	27	6	13	20	27
Tuesday	28	7	14	21	28
Wednesday	1	8	15	22	29
Thursday	2	9	16	23	30
Friday	3	10	17	24	31
Saturday	4	11	18	25	1
Sunday	5	12	19	26	2
Week	9	10	11	12	13

○

13 Monday / Montag / Lundi / Lunes / Lunedì / Segunda-feira / Maandag / 月曜日

14 Tuesday / Dienstag / Mardi / Martes / Martedì / Terça-feira / Dinsdag / 火曜日

15 Wednesday / Mittwoch / Mercredi / Miércoles / Mercoledì / Quarta-feira / Woensdag / 水曜日

16 Thursday / Donnerstag / Jeudi / Jueves / Giovedì / Quinta-feira / Donderdag / 木曜日

17 Friday / Freitag / Vendredi / Viernes / Venerdì / Sexta-feira / Vrijdag / 金曜日

18 Saturday / Samstag / Samedi / Sábado / Sabato / Sábado / Zaterdag / 土曜日

19 Sunday / Sonntag / Dimanche / Domingo / Domenica / Domingo / Zondag / 日曜日

WEEK 7

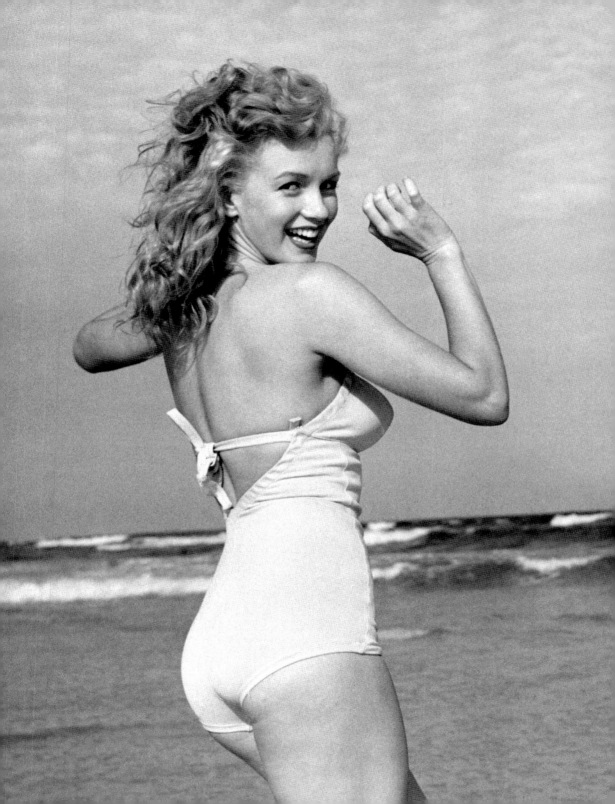

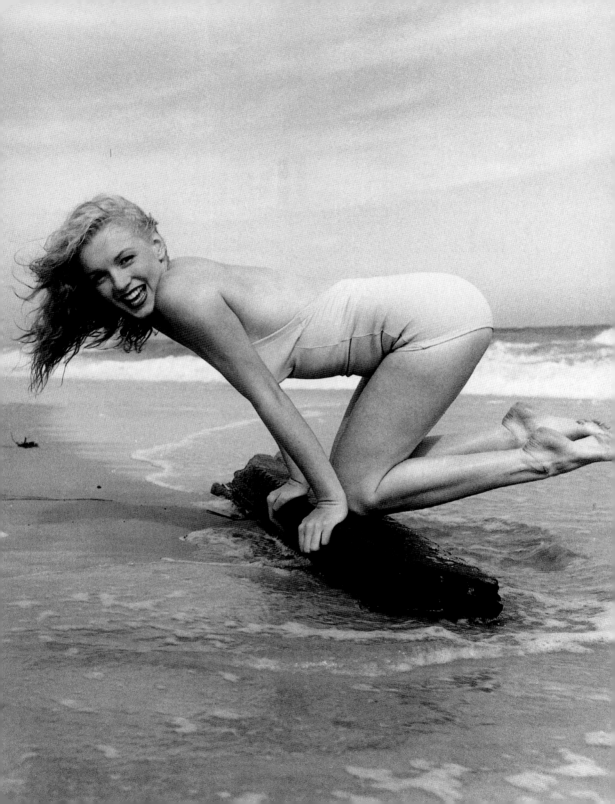

2006 FEBRUARY

FEBRUAR FEVRIER FEBRERO FEBBRAIO FEVEREIRO FEBRUARI 2月

JANUARY 2006						
Monday	26	2	9	16	23	30
Tuesday	27	3	10	17	24	31
Wednesday	28	4	11	18	25	1
Thursday	29	5	12	19	26	2
Friday	30	6	13	20	27	3
Saturday	31	7	14	21	28	4
Sunday	1	8	15	22	29	5
Week	52	1	2	3	4	5

FEBRUARY 2006					
Monday	30	6	13	20	27
Tuesday	31	7	14	21	28
Wednesday	1	8	15	22	1
Thursday	2	9	16	23	2
Friday	3	10	17	24	3
Saturday	4	11	18	25	4
Sunday	5	12	19	26	5
Week	5	6	7	8	9

MARCH 2006					
Monday	27	6	13	20	27
Tuesday	28	7	14	21	28
Wednesday	1	8	15	22	29
Thursday	2	9	16	23	30
Friday	3	10	17	24	31
Saturday	4	11	18	25	1
Sunday	5	12	19	26	2
Week	9	10	11	12	13

20
Monday
Montag
Lundi
Lunes
Lunedì
Segunda-feira
Maandag
月曜日

(USA) President's Day

21
Tuesday
Dienstag
Mardi
Martes
Martedì
Terça-feira
Dinsdag
火曜日

22
Wednesday
Mittwoch
Mercredi
Miércoles
Mercoledì
Quarta-feira
Woensdag
水曜日

23
Thursday
Donnerstag
Jeudi
Jueves
Giovedì
Quinta-feira
Donderdag
木曜日

24
Friday
Freitag
Vendredi
Viernes
Venerdì
Sexta-feira
Vrijdag
金曜日

25
Saturday
Samstag
Samedi
Sábado
Sabato
Sábado
Zaterdag
土曜日

26
Sunday
Sonntag
Dimanche
Domingo
Domenica
Domingo
Zondag
日曜日

WEEK 8

2006 MARCH MÄRZ MARS MARZO MARZO MARÇO MAART 3月

FEBRUARY 2006					
Monday	30	6	13	20	27
Tuesday	31	7	14	21	28
Wednesday	1	8	15	22	1
Thursday	2	9	16	23	2
Friday	3	10	17	24	3
Saturday	4	11	18	25	4
Sunday	5	12	19	26	5
Week	5	6	7	8	9

MARCH 2006					
Monday	27	6	13	20	27
Tuesday	28	7	14	21	28
Wednesday	1	8	15	22	29
Thursday	2	9	16	23	30
Friday	3	10	17	24	31
Saturday	4	11	18	25	1
Sunday	5	12	19	26	2
Week	9	10	11	12	13

APRIL 2006					
Monday	27	3	10	17	24
Tuesday	28	4	11	18	25
Wednesday	29	5	12	19	26
Thursday	30	6	13	20	27
Friday	31	7	14	21	28
Saturday	1	8	15	22	29
Sunday	2	9	16	23	30
Week	13	14	15	16	17

27
Monday
Montag
Lundi
Lunes
Lunedì
Segunda-feira
Maandag
月曜日

28
Tuesday
Dienstag
Mardi
Martes
Martedì
Terça-feira
Dinsdag
火曜日

ⓟ Terça-feira de Carnaval

1
Wednesday
Mittwoch
Mercredi
Miércoles
Mercoledì
Quarta-feira
Woensdag
水曜日

ⓇⓄⓀ Independence Movement Day

2
Thursday
Donnerstag
Jeudi
Jueves
Giovedì
Quinta-feira
Donderdag
木曜日

3
Friday
Freitag
Vendredi
Viernes
Venerdì
Sexta-feira
Vrijdag
金曜日

4
Saturday
Samstag
Samedi
Sábado
Sabato
Sábado
Zaterdag
土曜日

5
Sunday
Sonntag
Dimanche
Domingo
Domenica
Domingo
Zondag
日曜日

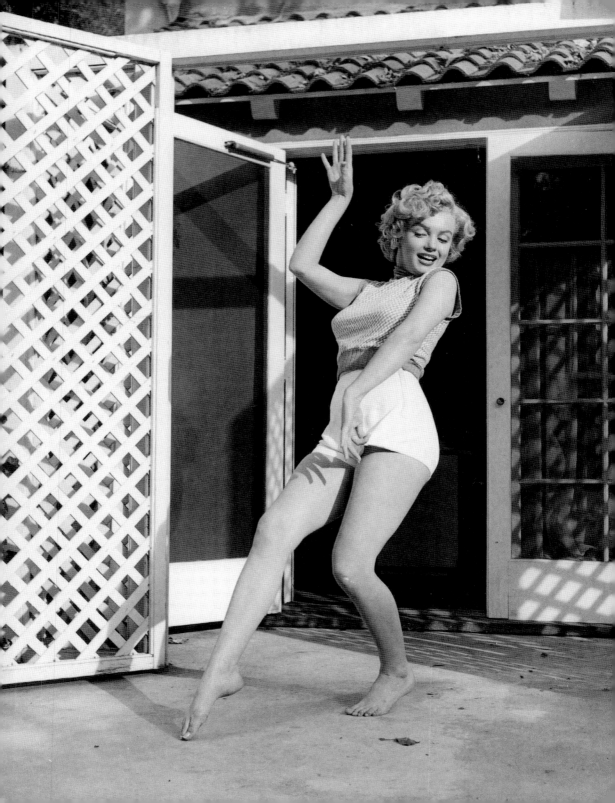

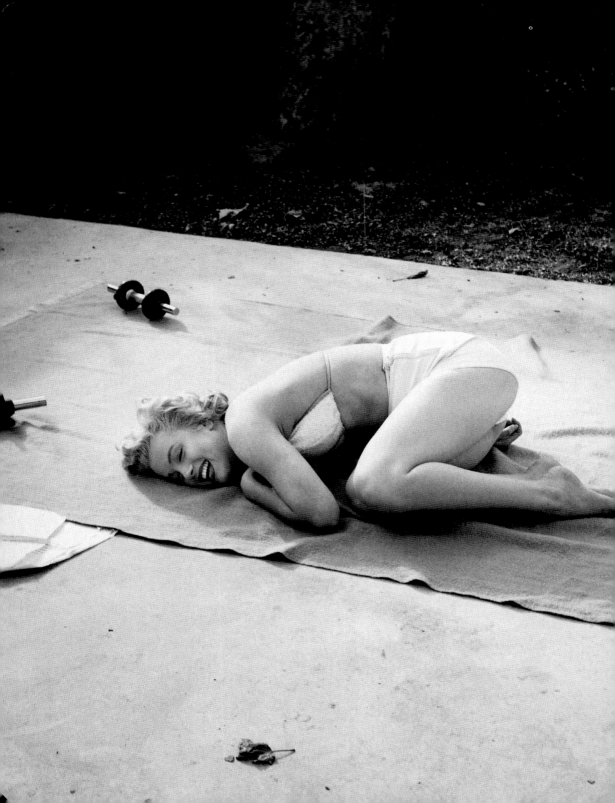

2006 MARCH MÄRZ MARS MARZO MARZO MARÇO MAART 3月

FEBRUARY 2006

Monday	30	6	13	20	27
Tuesday	31	7	14	21	28
Wednesday	1	8	15	22	1
Thursday	2	9	16	23	2
Friday	3	10	17	24	3
Saturday	4	11	18	25	4
Sunday	5	12	19	26	5
Week	5	6	7	8	9

MARCH 2006

Monday	27	6	13	20	27
Tuesday	28	7	14	21	28
Wednesday	1	8	15	22	29
Thursday	2	9	16	23	30
Friday	3	10	17	24	31
Saturday	4	11	18	25	1
Sunday	5	12	19	26	2
Week	9	10	11	12	13

APRIL 2006

Monday	27	3	10	17	24
Tuesday	28	4	11	18	25
Wednesday	29	5	12	19	26
Thursday	30	6	13	20	27
Friday	31	7	14	21	28
Saturday	1	8	15	22	29
Sunday	2	9	16	23	30
Week	13	14	15	16	17

6
Monday
Montag
Lundi
Lunes
Lunedì
Segunda-feira
Maandag
月曜日

7
Tuesday
Dienstag
Mardi
Martes
Martedì
Terça-feira
Dinsdag
火曜日

8
Wednesday
Mittwoch
Mercredi
Miércoles
Mercoledì
Quarta-feira
Woensdag
水曜日

9
Thursday
Donnerstag
Jeudi
Jueves
Giovedì
Quinta-feira
Donderdag
木曜日

10
Friday
Freitag
Vendredi
Viernes
Venerdì
Sexta-feira
Vrijdag
金曜日

11
Saturday
Samstag
Samedi
Sábado
Sabato
Sábado
Zaterdag
土曜日

12
Sunday
Sonntag
Dimanche
Domingo
Domenica
Domingo
Zondag
日曜日

WEEK 10

2006 MARCH

MÄRZ MARS MARZO MARZO MARÇO MAART 3月

FEBRUARY 2006

Monday	30	6	13	20	27
Tuesday	31	7	14	21	28
Wednesday	1	8	15	22	1
Thursday	2	9	16	23	2
Friday	3	10	17	24	3
Saturday	4	11	18	25	4
Sunday	5	12	19	26	5
Week	5	6	7	8	9

MARCH 2006

Monday	27	6	13	20	27
Tuesday	28	7	14	21	28
Wednesday	1	8	15	22	29
Thursday	2	9	16	23	30
Friday	3	10	17	24	31
Saturday	4	11	18	25	1
Sunday	5	12	19	26	2
Week	9	10	11	12	13

APRIL 2006

Monday	27	3	10	17	24
Tuesday	28	4	11	18	25
Wednesday	29	5	12	19	26
Thursday	30	6	13	20	27
Friday	31	7	14	21	28
Saturday	1	8	15	22	29
Sunday	2	9	16	23	30
Week	13	14	15	16	17

13
Monday
Montag
Lundi
Lunes
Lunedì
Segunda-feira
Maandag
月曜日

14
Tuesday
Dienstag
Mardi
Martes
Martedì
Terça-feira
Dinsdag
火曜日

(IL) Purim

15
Wednesday
Mittwoch
Mercredi
Miércoles
Mercoledì
Quarta-feira
Woensdag
水曜日

16
Thursday
Donnerstag
Jeudi
Jueves
Giovedì
Quinta-feira
Donderdag
木曜日

17
Friday
Freitag
Vendredi
Viernes
Venerdì
Sexta-feira
Vrijdag
金曜日

(UK) Saint Patrick's Day
(Northern Ireland only)
(IRL) Saint Patrick's Day

18
Saturday
Samstag
Samedi
Sábado
Sabato
Sábado
Zaterdag
土曜日

19
Sunday
Sonntag
Dimanche
Domingo
Domenica
Domingo
Zondag
日曜日

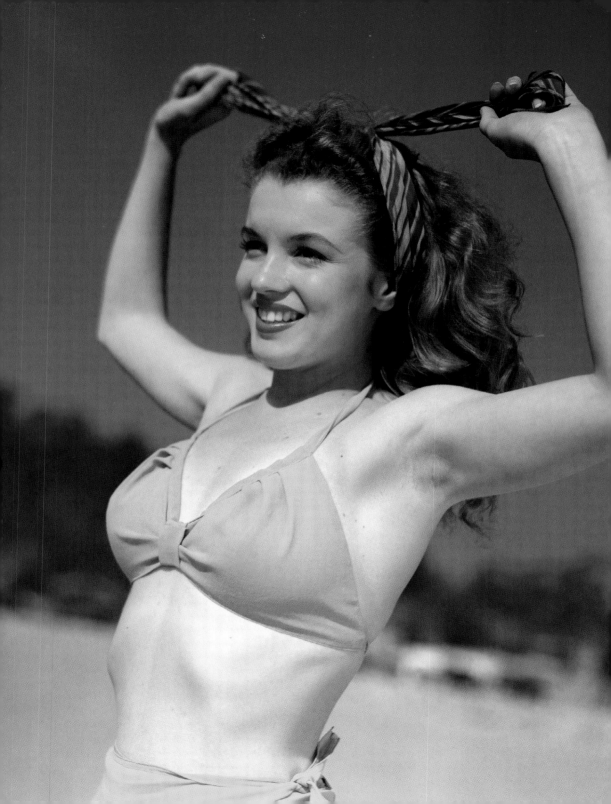

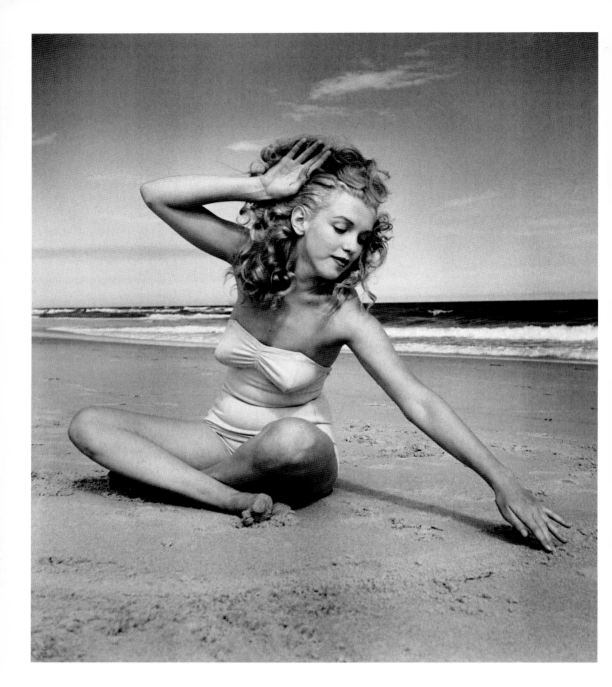

2006 MARCH MÄRZ MARS MARZO MARZO MARÇO MAART 3月

FEBRUARY 2006

Monday	30	6	13	20	27
Tuesday	31	7	14	21	28
Wednesday	1	8	15	22	1
Thursday	2	9	16	23	2
Friday	3	10	17	24	3
Saturday	4	11	18	25	4
Sunday	5	12	19	26	5
Week	5	6	7	8	9

MARCH 2006

Monday	27	6	13	20	27
Tuesday	28	7	14	21	28
Wednesday	1	8	15	22	29
Thursday	2	9	16	23	30
Friday	3	10	17	24	31
Saturday	4	11	18	25	1
Sunday	5	12	19	26	2
Week	9	10	11	12	13

APRIL 2006

Monday	27	3	10	17	24
Tuesday	28	4	11	18	25
Wednesday	29	5	12	19	26
Thursday	30	6	13	20	27
Friday	31	7	14	21	28
Saturday	1	8	15	22	29
Sunday	2	9	16	23	30
Week	13	14	15	16	17

20
Monday
Montag
Lundi
Lunes
Lunedì
Segunda-feira
Maandag
月曜日

21
Tuesday
Dienstag
Mardi
Martes
Martedì
Terça-feira
Dinsdag
火曜日

Ⓙ Vernal Equinox Day

22
Wednesday
Mittwoch
Mercredi
Miércoles
Mercoledì
Quarta-feira
Woensdag
水曜日

23
Thursday
Donnerstag
Jeudi
Jueves
Giovedì
Quinta-feira
Donderdag
木曜日

24
Friday
Freitag
Vendredi
Viernes
Venerdì
Sexta-feira
Vrijdag
金曜日

25
Saturday
Samstag
Samedi
Sábado
Sabato
Sábado
Zaterdag
土曜日

26
Sunday
Sonntag
Dimanche
Domingo
Domenica
Domingo
Zondag
日曜日

2006 APRIL APRIL AVRIL ABRIL APRILE ABRIL APRIL 4月

MARCH 2006

Monday	27	6	13	20	27
Tuesday	28	7	14	21	28
Wednesday	1	8	15	22	29
Thursday	2	9	16	23	30
Friday	3	10	17	24	31
Saturday	4	11	18	25	1
Sunday	5	12	19	26	2
Week	9	10	11	12	13

APRIL 2006

Monday	27	3	10	17	24
Tuesday	28	4	11	18	25
Wednesday	29	5	12	19	26
Thursday	30	6	13	20	27
Friday	31	7	14	21	28
Saturday	1	8	15	22	29
Sunday	2	9	16	23	30
Week	13	14	15	16	17

MAY 2006

Monday	24	1	8	15	22	29
Tuesday	25	2	9	16	23	30
Wednesday	26	3	10	17	24	31
Thursday	27	4	11	18	25	1
Friday	28	5	12	19	26	2
Saturday	29	6	13	20	27	3
Sunday	30	7	14	21	28	4
Week	17	18	19	20	21	22

27
Monday
Montag
Lundi
Lunes
Lunedì
Segunda-feira
Maandag
月曜日

28
Tuesday
Dienstag
Mardi
Martes
Martedì
Terça-feira
Dinsdag
火曜日

29
● Wednesday
Mittwoch
Mercredi
Miércoles
Mercoledì
Quarta-feira
Woensdag
水曜日

30
Thursday
Donnerstag
Jeudi
Jueves
Giovedì
Quinta-feira
Donderdag
木曜日

31
Friday
Freitag
Vendredi
Viernes
Venerdì
Sexta-feira
Vrijdag
金曜日

1
Saturday
Samstag
Samedi
Sábado
Sabato
Sábado
Zaterdag
土曜日

2
Sunday
Sonntag
Dimanche
Domingo
Domenica
Domingo
Zondag
日曜日

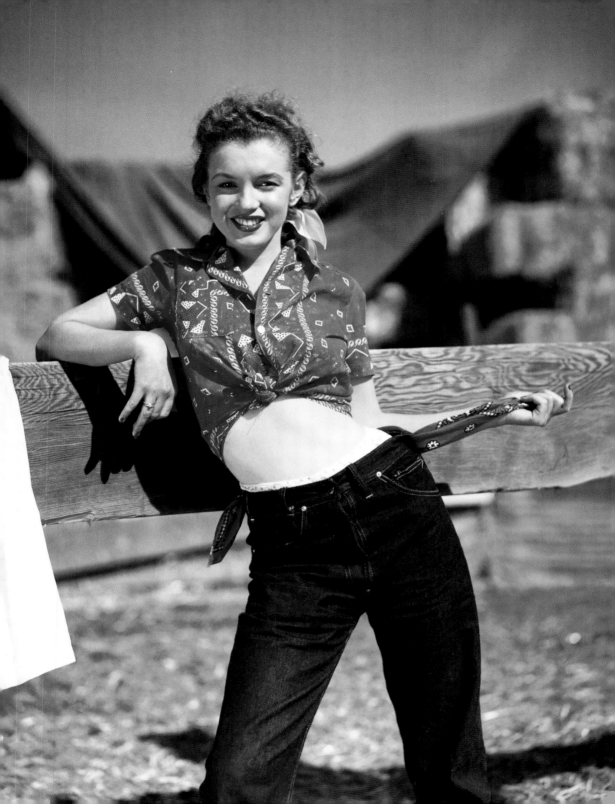

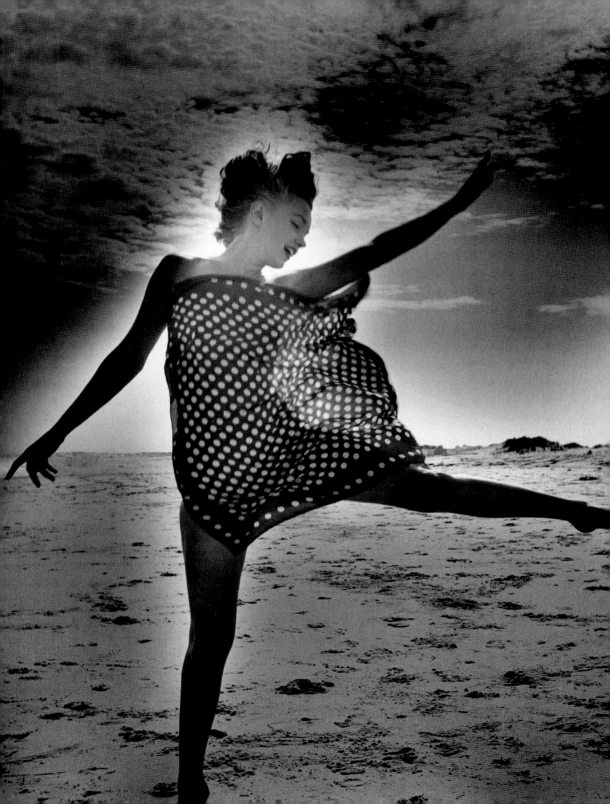

MARCH 2006

Monday	27	6	13	20	27
Tuesday	28	7	14	21	28
Wednesday	1	8	15	22	29
Thursday	2	9	16	23	30
Friday	3	10	17	24	31
Saturday	4	11	18	25	1
Sunday	5	12	19	26	2
Week	9	10	11	12	13

APRIL 2006

Monday	27	3	10	17	24
Tuesday	28	4	11	18	25
Wednesday	29	5	12	19	26
Thursday	30	6	13	20	27
Friday	31	7	14	21	28
Saturday	1	8	15	22	29
Sunday	2	9	16	23	30
Week	13	14	15	16	17

MAY 2006

Monday	24	1	8	15	22	29
Tuesday	25	2	9	16	23	30
Wednesday	26	3	10	17	24	31
Thursday	27	4	11	18	25	1
Friday	28	5	12	19	26	2
Saturday	29	6	13	20	27	3
Sunday	30	7	14	21	28	4
Week	17	18	19	20	21	22

3
Monday
Montag
Lundi
Lunes
Lunedì
Segunda-feira
Maandag
月曜日

4
Tuesday
Dienstag
Mardi
Martes
Martedì
Terça-feira
Dinsdag
火曜日

5
Wednesday
Mittwoch
Mercredi
Miércoles
Mercoledì
Quarta-feira
Woensdag
水曜日

(ROK) Arbor Day

6
Thursday
Donnerstag
Jeudi
Jueves
Giovedì
Quinta-feira
Donderdag
木曜日

7
Friday
Freitag
Vendredi
Viernes
Venerdì
Sexta-feira
Vrijdag
金曜日

8
Saturday
Samstag
Samedi
Sábado
Sabato
Sábado
Zaterdag
土曜日

9
Sunday
Sonntag
Dimanche
Domingo
Domenica
Domingo
Zondag
日曜日

MARCH 2006					
Monday	27	6	13	20	27
Tuesday	28	7	14	21	28
Wednesday	1	8	15	22	29
Thursday	2	9	16	23	30
Friday	3	10	17	24	31
Saturday	4	11	18	25	1
Sunday	5	12	19	26	2
Week	9	10	11	12	13

APRIL 2006					
Monday	27	3	10	17	24
Tuesday	28	4	11	18	25
Wednesday	29	5	12	19	26
Thursday	30	6	13	20	27
Friday	31	7	14	21	28
Saturday	1	8	15	22	29
Sunday	2	9	16	23	30
Week	13	14	15	16	17

MAY 2006						
Monday	24	1	8	15	22	29
Tuesday	25	2	9	16	23	30
Wednesday	26	3	10	17	24	31
Thursday	27	4	11	18	25	1
Friday	28	5	12	19	26	2
Saturday	29	6	13	20	27	3
Sunday	30	7	14	21	28	4
Week	17	18	19	20	21	22

10
Monday
Montag
Lundi
Lunes
Lunedì
Segunda-feira
Maandag
月曜日

11
Tuesday
Dienstag
Mardi
Martes
Martedì
Terça-feira
Dinsdag
火曜日

12
Wednesday
Mittwoch
Mercredi
Miércoles
Mercoledì
Quarta-feira
Woensdag
水曜日

13
Thursday
Donnerstag
Jeudi
Jueves
Giovedì
Quinta-feira
Donderdag
木曜日

(IL) Passover

14
Friday
Freitag
Vendredi
Viernes
Venerdì
Sexta-feira
Vrijdag
金曜日

(UK) (CDN) (D) (CH) (E) (P)
Good Friday | Vendredi Saint |
Karfreitag | Venerdì Santo |
Viernes Santo | Sexta-feira Santa

15
Saturday
Samstag
Samedi
Sábado
Sabato
Sábado
Zaterdag
土曜日

16
Sunday
Sonntag
Dimanche
Domingo
Domenica
Domingo
Zondag
日曜日

Easter Sunday | Pâques | Ostersonntag |
Ostern | Pasqua | 1e Paasdag | Pascua |
Domingo de Páscoa

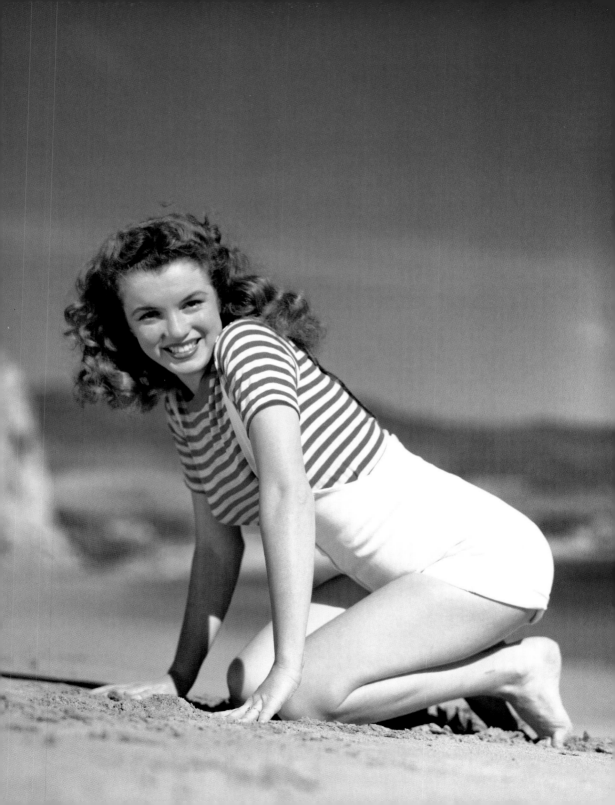

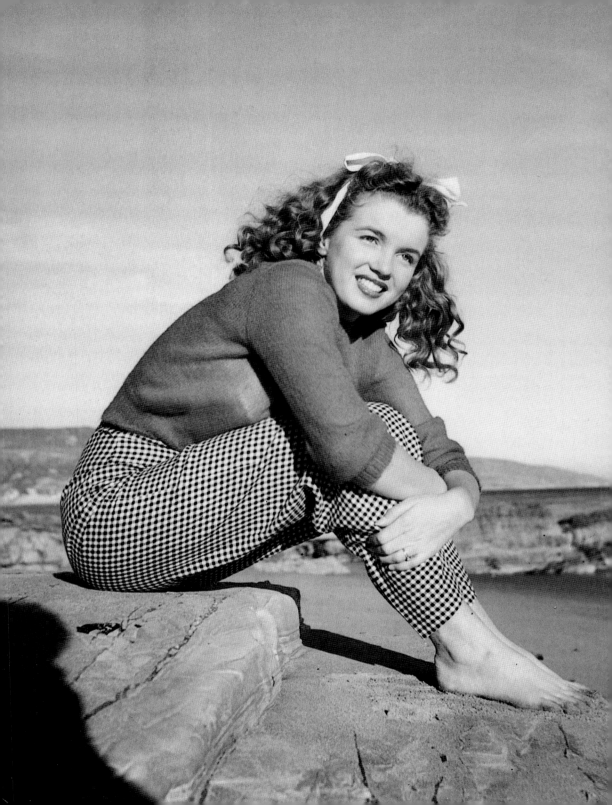

2006 APRIL
APRIL AVRIL ABRIL APRILE ABRIL APRIL 4月

MARCH 2006

Monday	27	6	13	20	27
Tuesday	28	7	14	21	28
Wednesday	1	8	15	22	29
Thursday	2	9	16	23	30
Friday	3	10	17	24	31
Saturday	4	11	18	25	1
Sunday	5	12	19	26	2
Week	9	10	11	12	13

APRIL 2006

Monday	27	3	10	17	24
Tuesday	28	4	11	18	25
Wednesday	29	5	12	19	26
Thursday	30	6	13	20	27
Friday	31	7	14	21	28
Saturday	1	8	15	22	29
Sunday	2	9	16	23	30
Week	13	14	15	16	17

MAY 2006

Monday	24	1	8	15	22	29
Tuesday	25	2	9	16	23	30
Wednesday	26	3	10	17	24	31
Thursday	27	4	11	18	25	1
Friday	28	5	12	19	26	2
Saturday	29	6	13	20	27	3
Sunday	30	7	14	21	28	4
Week	17	18	19	20	21	22

17

Monday
Montag
Lundi
Lunes
Lunedì
Segunda-feira
Maandag
月曜日

(UK) Easter Monday (except Scotland)

(IRL) (CDN) (F) (D) (A) (CH) (NL) (I)

Easter Monday | Lundi de Pâques |

Ostermontag | Lunedì di Pasqua |

2e Paasdag | Lunedì dell'Angelo

18

Tuesday
Dienstag
Mardi
Martes
Martedì
Terça-feira
Dinsdag
火曜日

19

Wednesday
Mittwoch
Mercredi
Miércoles
Mercoledì
Quarta-feira
Woensdag
水曜日

(IL) Passover

20

Thursday
Donnerstag
Jeudi
Jueves
Giovedì
Quinta-feira
Donderdag
木曜日

21

Friday
Freitag
Vendredi
Viernes
Venerdì
Sexta-feira
Vrijdag
金曜日

22

Saturday
Samstag
Samedi
Sábado
Sabato
Sábado
Zaterdag
土曜日

23

Sunday
Sonntag
Dimanche
Domingo
Domenica
Domingo
Zondag
日曜日

WEEK 16

2006 APRIL APRIL AVRIL ABRIL APRILE ABRIL APRIL 4月

MARCH 2006					
Monday	27	6	13	20	27
Tuesday	28	7	14	21	28
Wednesday	1	8	15	22	29
Thursday	2	9	16	23	30
Friday	3	10	17	24	31
Saturday	4	11	18	25	1
Sunday	5	12	19	26	2
Week	9	10	11	12	13

APRIL 2006					
Monday	27	3	10	17	24
Tuesday	28	4	11	18	25
Wednesday	29	5	12	19	26
Thursday	30	6	13	20	27
Friday	31	7	14	21	28
Saturday	1	8	15	22	29
Sunday	2	9	16	23	30
Week	13	14	15	16	17

MAY 2006						
Monday	24	1	8	15	22	29
Tuesday	25	2	9	16	23	30
Wednesday	26	3	10	17	24	31
Thursday	27	4	11	18	25	1
Friday	28	5	12	19	26	2
Saturday	29	6	13	20	27	3
Sunday	30	7	14	21	28	4
Week	17	18	19	20	21	22

24
Monday
Montag
Lundi
Lunes
Lunedì
Segunda-feira
Maandag
月曜日

25
Tuesday
Dienstag
Mardi
Martes
Martedì
Terça-feira
Dinsdag
火曜日

(IL) Yom Hashoah
(I) Liberazione
(P) Dia da Liberdade

26
Wednesday
Mittwoch
Mercredi
Miércoles
Mercoledì
Quarta-feira
Woensdag
水曜日

27
Thursday
Donnerstag
Jeudi
Jueves
Giovedì
Quinta-feira
Donderdag
木曜日

28
Friday
Freitag
Vendredi
Viernes
Venerdì
Sexta-feira
Vrijdag
金曜日

29
Saturday
Samstag
Samedi
Sábado
Sabato
Sábado
Zaterdag
土曜日

(J) Greenery Day

30
Sunday
Sonntag
Dimanche
Domingo
Domenica
Domingo
Zondag
日曜日

(NL) Koninginnedag

WEEK 17

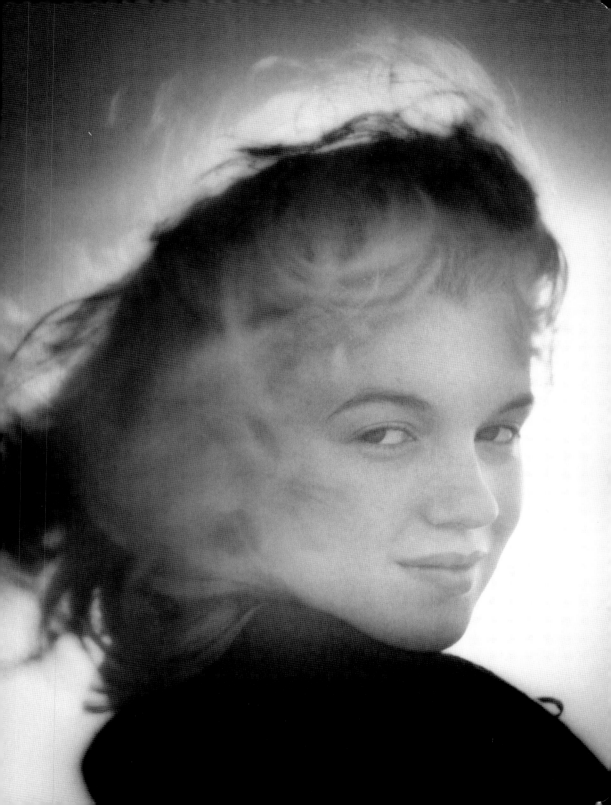

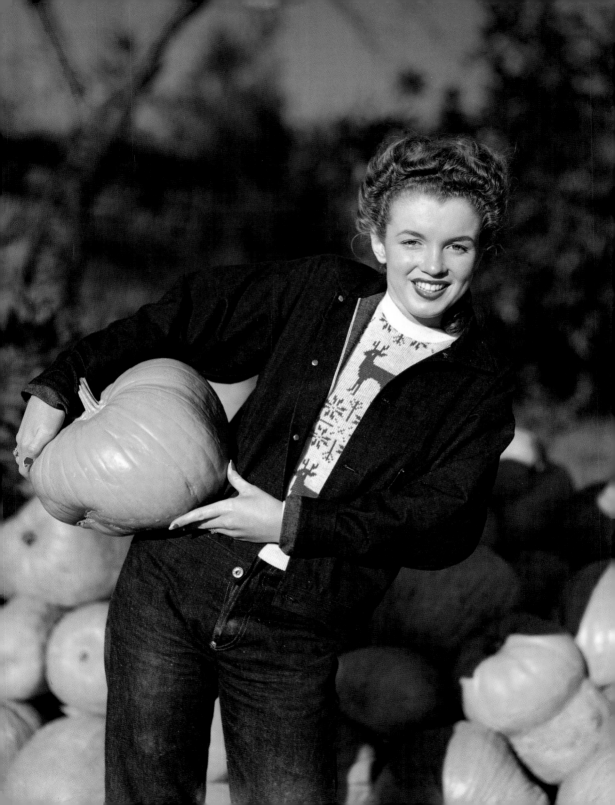

2006 MAY MAI MAI MAYO MAGGIO MAIO MEI 5月

APRIL 2006						MAY 2006						JUNE 2006						
Monday	27	3	10	17	24	Monday	24	1	8	15	22	29	Monday	29	5	12	19	26
Tuesday	28	4	11	18	25	Tuesday	25	2	9	16	23	30	Tuesday	30	6	13	20	27
Wednesday	29	5	12	19	26	Wednesday	26	3	10	17	24	31	Wednesday	31	7	14	21	28
Thursday	30	6	13	20	27	Thursday	27	4	11	18	25	1	Thursday	1	8	15	22	29
Friday	31	7	14	21	28	Friday	28	5	12	19	26	2	Friday	2	9	16	23	30
Saturday	1	8	15	22	29	Saturday	29	6	13	20	27	3	Saturday	3	10	17	24	1
Sunday	2	9	16	23	30	Sunday	30	7	14	21	28	4	Sunday	4	11	18	25	2
Week	13	14	15	16	17	Week	17	18	19	20	21	22	Week	22	23	24	25	26

1

Monday
Montag
Lundi
Lunes
Lunedì
Segunda-feira
Maandag
月曜日

(UK) Early May Bank Holiday
(IRL) First Monday in May
(F) (D) (A) (E) (I) (P)
Fête du Travail | Maifeiertag | Fiesta del
Trabajo | Festa del Lavoro | Dia do Trabalho
(IL) Passover

2

Tuesday
Dienstag
Mardi
Martes
Martedì
Terça-feira
Dinsdag
火曜日

3

Wednesday
Mittwoch
Mercredi
Miércoles
Mercoledì
Quarta-feira
Woensdag
水曜日

(J) Constitution Day
(IL) Yom Haatzmaut

4

Thursday
Donnerstag
Jeudi
Jueves
Giovedì
Quinta-feira
Donderdag
木曜日

(J) Public Holiday

5

Friday
Freitag
Vendredi
Viernes
Venerdì
Sexta-feira
Vrijdag
金曜日

(J) (ROK) Children's Day
(ROK) Buddha's Birthday

6

Saturday
Samstag
Samedi
Sábado
Sabato
Sábado
Zaterdag
土曜日

7

Sunday
Sonntag
Dimanche
Domingo
Domenica
Domingo
Zondag
日曜日

2006 MAY MAI MAI MAYO MAGGIO MAIO MEI 5月

APRIL 2006						MAY 2006						JUNE 2006						
Monday	27	3	10	17	24	Monday	24	1	8	15	22	29	Monday	29	5	12	19	26
Tuesday	28	4	11	18	25	Tuesday	25	2	9	16	23	30	Tuesday	30	6	13	20	27
Wednesday	29	5	12	19	26	Wednesday	26	3	10	17	24	31	Wednesday	31	7	14	21	28
Thursday	30	6	13	20	27	Thursday	27	4	11	18	25	1	Thursday	1	8	15	22	29
Friday	31	7	14	21	28	Friday	28	5	12	19	26	2	Friday	2	9	16	23	30
Saturday	1	8	15	22	29	Saturday	29	6	13	20	27	3	Saturday	3	10	17	24	1
Sunday	2	9	16	23	30	Sunday	30	7	14	21	28	4	Sunday	4	11	18	25	2
Week	13	14	15	16	17	Week	17	18	19	20	21	22	Week	22	23	24	25	26

8
Monday
Montag
Lundi
Lunes
Lunedì
Segunda-feira
Maandag
月曜日

Ⓕ Fête de la Libération

9
Tuesday
Dienstag
Mardi
Martes
Martedì
Terça-feira
Dinsdag
火曜日

10
Wednesday
Mittwoch
Mercredi
Miércoles
Mercoledì
Quarta-feira
Woensdag
水曜日

11
Thursday
Donnerstag
Jeudi
Jueves
Giovedì
Quinta-feira
Donderdag
木曜日

12
Friday
Freitag
Vendredi
Viernes
Venerdì
Sexta-feira
Vrijdag
金曜日

○
13
Saturday
Samstag
Samedi
Sábado
Sabato
Sábado
Zaterdag
土曜日

14
Sunday
Sonntag
Dimanche
Domingo
Domenica
Domingo
Zondag
日曜日

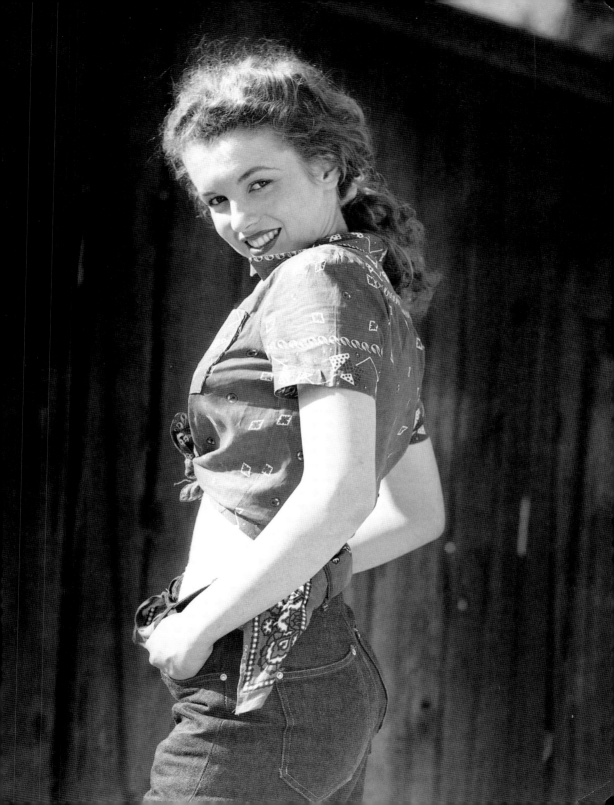

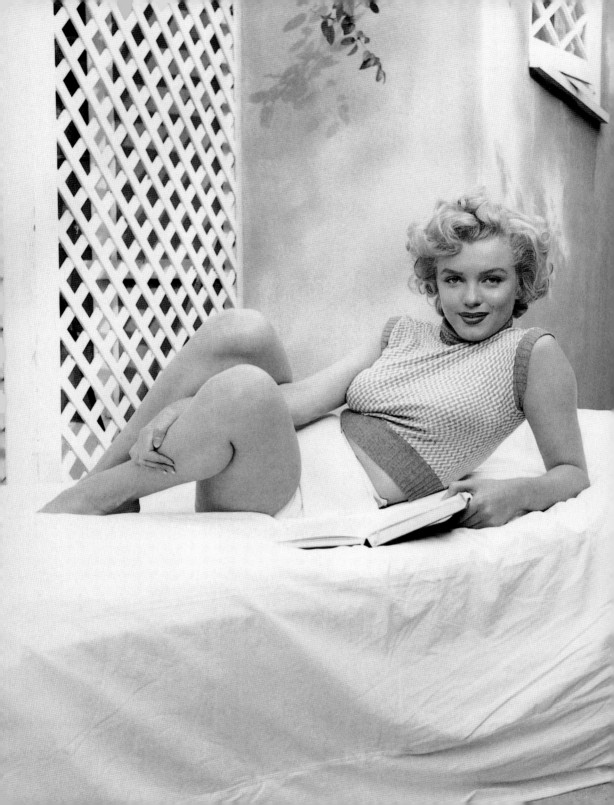

2006 MAY MAI MAI MAYO MAGGIO MAIO MEI 5月

APRIL 2006					
Monday	27	3	10	17	24
Tuesday	28	4	11	18	25
Wednesday	29	5	12	19	26
Thursday	30	6	13	20	27
Friday	31	7	14	21	28
Saturday	1	8	15	22	29
Sunday	2	9	16	23	30
Week	13	14	15	16	17

MAY 2006						
Monday	24	1	8	15	22	29
Tuesday	25	2	9	16	23	30
Wednesday	26	3	10	17	24	31
Thursday	27	4	11	18	25	1
Friday	28	5	12	19	26	2
Saturday	29	6	13	20	27	3
Sunday	30	7	14	21	28	4
Week	17	18	19	20	21	22

JUNE 2006					
Monday	29	5	12	19	26
Tuesday	30	6	13	20	27
Wednesday	31	7	14	21	28
Thursday	1	8	15	22	29
Friday	2	9	16	23	30
Saturday	3	10	17	24	1
Sunday	4	11	18	25	2
Week	22	23	24	25	26

15
Monday
Montag
Lundi
Lunes
Lunedì
Segunda-feira
Maandag
月曜日

16
Tuesday
Dienstag
Mardi
Martes
Martedì
Terça-feira
Dinsdag
火曜日

17
Wednesday
Mittwoch
Mercredi
Miércoles
Mercoledì
Quarta-feira
Woensdag
水曜日

18
Thursday
Donnerstag
Jeudi
Jueves
Giovedì
Quinta-feira
Donderdag
木曜日

19
Friday
Freitag
Vendredi
Viernes
Venerdì
Sexta-feira
Vrijdag
金曜日

20
Saturday
Samstag
Samedi
Sábado
Sabato
Sábado
Zaterdag
土曜日

21
Sunday
Sonntag
Dimanche
Domingo
Domenica
Domingo
Zondag
日曜日

WEEK 20

2006 MAY MAI MAI MAYO MAGGIO MAIO MEI 5月

APRIL 2006						MAY 2006						JUNE 2006						
Monday	27	3	10	17	24	Monday	24	1	8	15	22	29	Monday	29	5	12	19	26
Tuesday	28	4	11	18	25	Tuesday	25	2	9	16	23	30	Tuesday	30	6	13	20	27
Wednesday	29	5	12	19	26	Wednesday	26	3	10	17	24	31	Wednesday	31	7	14	21	28
Thursday	30	6	13	20	27	Thursday	27	4	11	18	25	1	Thursday	1	8	15	22	29
Friday	31	7	14	21	28	Friday	28	5	12	19	26	2	Friday	2	9	16	23	30
Saturday	1	8	15	22	29	Saturday	29	6	13	20	27	3	Saturday	3	10	17	24	1
Sunday	2	9	16	23	30	Sunday	30	7	14	21	28	4	Sunday	4	11	18	25	2
Week	13	14	15	16	17	Week	17	18	19	20	21	22	Week	22	23	24	25	26

22
Monday / Montag / Lundi / Lunes / Lunedì / Segunda-feira / Maandag / 月曜日

(CDN) Victoria Day | Fête de la Reine

23
Tuesday / Dienstag / Mardi / Martes / Martedì / Terça-feira / Dinsdag / 火曜日

24
Wednesday / Mittwoch / Mercredi / Miércoles / Mercoledì / Quarta-feira / Woensdag / 水曜日

25
Thursday / Donnerstag / Jeudi / Jueves / Giovedì / Quinta-feira / Donderdag / 木曜日

(F) (D) (A) (CH) (NL)
Ascension | Christi Himmelfahrt | Auffahrt | Ascensione | Hemelvaartsdag

26
Friday / Freitag / Vendredi / Viernes / Venerdì / Sexta-feira / Vrijdag / 金曜日

27
● Saturday / Samstag / Samedi / Sábado / Sabato / Sábado / Zaterdag / 土曜日

28
Sunday / Sonntag / Dimanche / Domingo / Domenica / Domingo / Zondag / 日曜日

WEEK 21

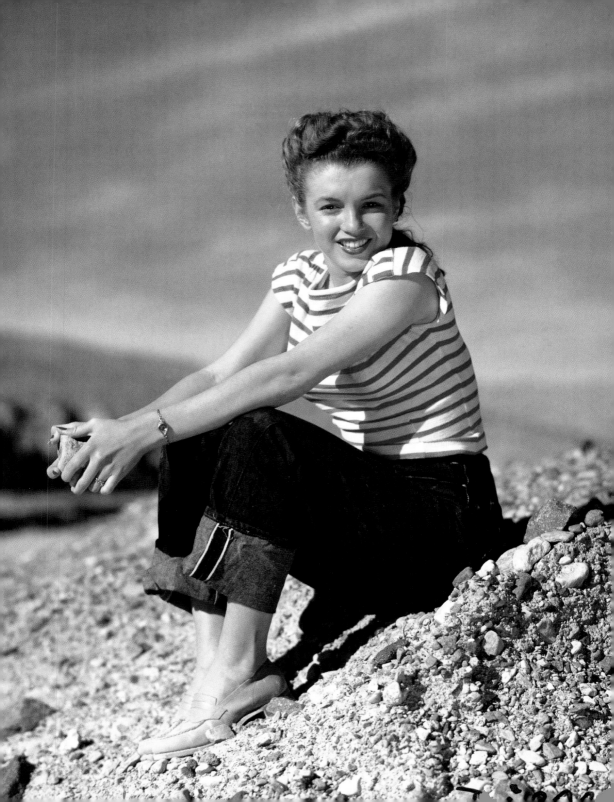

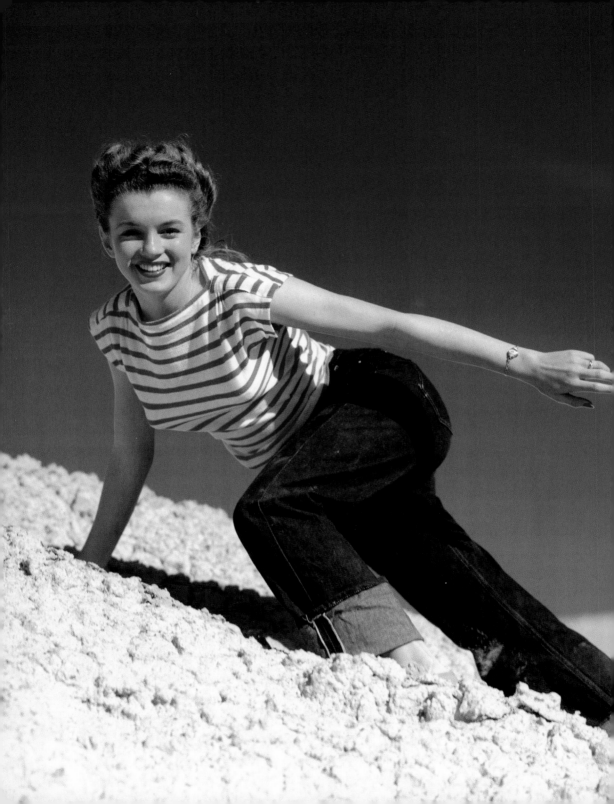

2006 JUNE JUNI JUIN JUNIO GIUGNO JUNHO JUNI 6月

MAY 2006

Monday	24	1	8	15	22	29
Tuesday	25	2	9	16	23	30
Wednesday	26	3	10	17	24	31
Thursday	27	4	11	18	25	1
Friday	28	5	12	19	26	2
Saturday	29	6	13	20	27	3
Sunday	30	7	14	21	28	4
Week	17	18	19	20	21	22

JUNE 2006

Monday	29	5	12	19	26	
Tuesday	30	6	13	20	27	
Wednesday	31	7	14	21	28	
Thursday	1	8	15	22	29	
Friday	2	9	16	23	30	
Saturday	3	10	17	24	1	
Sunday	4	11	18	25	2	
Week	22	23	24	25	26	

JULY 2006

Monday	26	3	10	17	24	31
Tuesday	27	4	11	18	25	1
Wednesday	28	5	12	19	26	2
Thursday	29	6	13	20	27	3
Friday	30	7	14	21	28	4
Saturday	1	8	15	22	29	5
Sunday	2	9	16	23	30	6
Week	26	27	28	29	30	31

29
Monday
Montag
Lundi
Lunes
Lunedì
Segunda-feira
Maandag
月曜日

(USA) Memorial Day
(UK) Spring Bank Holiday

30
Tuesday
Dienstag
Mardi
Martes
Martedì
Terça-feira
Dinsdag
火曜日

31
Wednesday
Mittwoch
Mercredi
Miércoles
Mercoledì
Quarta-feira
Woensdag
水曜日

1
Thursday
Donnerstag
Jeudi
Jueves
Giovedì
Quinta-feira
Donderdag
木曜日

2
Friday
Freitag
Vendredi
Viernes
Venerdì
Sexta-feira
Vrijdag
金曜日

(I) Festa della Repubblica
(IL) Shavuot

3
Saturday
Samstag
Samedi
Sábado
Sabato
Sábado
Zaterdag
土曜日

4
Sunday
Sonntag
Dimanche
Domingo
Domenica
Domingo
Zondag
日曜日

(F) (D) (A) (CH) (NL)
Pentecôte | Pfingstsonntag |
Pentecoste | 1e Pinksterdag

WEEK 22

2006 JUNE JUNI JUIN JUNIO GIUGNO JUNHO JUNI 6月

MAY 2006

Monday	24	1	8	15	22	29
Tuesday	25	2	9	16	23	30
Wednesday	26	3	10	17	24	31
Thursday	27	4	11	18	25	1
Friday	28	5	12	19	26	2
Saturday	29	6	13	20	27	3
Sunday	30	7	14	21	28	4
Week	17	18	19	20	21	22

JUNE 2006

Monday	29	5	12	19	26	
Tuesday	30	6	13	20	27	
Wednesday	31	7	14	21	28	
Thursday	1	8	15	22	29	
Friday	2	9	16	23	30	
Saturday	3	10	17	24	1	
Sunday	4	11	18	25	2	
Week	22	23	24	25	26	

JULY 2006

Monday	26	3	10	17	24	31
Tuesday	27	4	11	18	25	1
Wednesday	28	5	12	19	26	2
Thursday	29	6	13	20	27	3
Friday	30	7	14	21	28	4
Saturday	1	8	15	22	29	5
Sunday	2	9	16	23	30	6
Week	26	27	28	29	30	31

5
Monday
Montag
Lundi
Lunes
Lunedì
Segunda-feira
Maandag
月曜日

(IRL) First Monday in June

(F) (D) (A) (CH) (NL)

Lundi de Pentecôte | Pfingstmontag |

Lunedì di Pentecoste | 2e Pinksterdag

6
Tuesday
Dienstag
Mardi
Martes
Martedì
Terça-feira
Dinsdag
火曜日

(ROK) Memorial Day

7
Wednesday
Mittwoch
Mercredi
Miércoles
Mercoledì
Quarta-feira
Woensdag
水曜日

8
Thursday
Donnerstag
Jeudi
Jueves
Giovedì
Quinta-feira
Donderdag
木曜日

9
Friday
Freitag
Vendredi
Viernes
Venerdì
Sexta-feira
Vrijdag
金曜日

10
Saturday
Samstag
Samedi
Sábado
Sabato
Sábado
Zaterdag
土曜日

(P) Dia Nacional

11
○
Sunday
Sonntag
Dimanche
Domingo
Domenica
Domingo
Zondag
日曜日

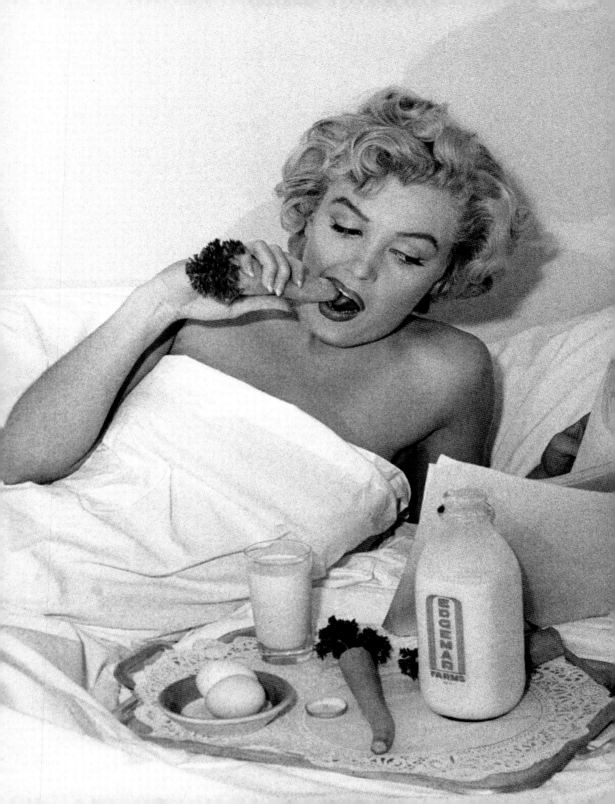

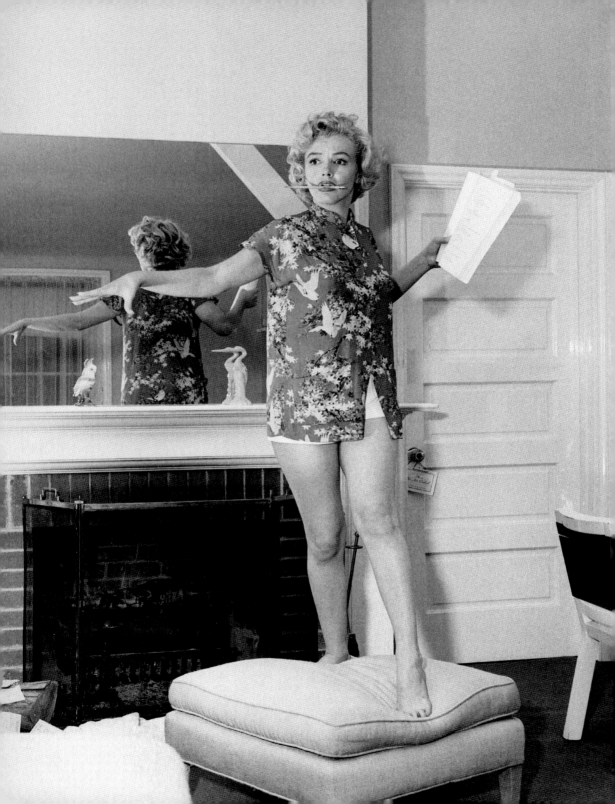

2006 JUNE JUNI JUIN JUNIO GIUGNO JUNHO JUNI 6月

MAY 2006						
Monday	24	1	8	15	22	29
Tuesday	25	2	9	16	23	30
Wednesday	26	3	10	17	24	31
Thursday	27	4	11	18	25	1
Friday	28	5	12	19	26	2
Saturday	29	6	13	20	27	3
Sunday	30	7	14	21	28	4
Week	17	18	19	20	21	22

JUNE 2006					
Monday	29	5	12	19	26
Tuesday	30	6	13	20	27
Wednesday	31	7	14	21	28
Thursday	1	8	15	22	29
Friday	2	9	16	23	30
Saturday	3	10	17	24	1
Sunday	4	11	18	25	2
Week	22	23	24	25	26

JULY 2006						
Monday	26	3	10	17	24	31
Tuesday	27	4	11	18	25	1
Wednesday	28	5	12	19	26	2
Thursday	29	6	13	20	27	3
Friday	30	7	14	21	28	4
Saturday	1	8	15	22	29	5
Sunday	2	9	16	23	30	6
Week	26	27	28	29	30	31

12
Monday
Montag
Lundi
Lunes
Lunedì
Segunda-feira
Maandag
月曜日

13
Tuesday
Dienstag
Mardi
Martes
Martedì
Terça-feira
Dinsdag
火曜日

14
Wednesday
Mittwoch
Mercredi
Miércoles
Mercoledì
Quarta-feira
Woensdag
水曜日

15
Thursday
Donnerstag
Jeudi
Jueves
Giovedì
Quinta-feira
Donderdag
木曜日

(D) Fronleichnam (teilweise)
(A) Fronleichnam
(P) Corpo de Deus

16
Friday
Freitag
Vendredi
Viernes
Venerdì
Sexta-feira
Vrijdag
金曜日

17
Saturday
Samstag
Samedi
Sábado
Sabato
Sábado
Zaterdag
土曜日

18
Sunday
Sonntag
Dimanche
Domingo
Domenica
Domingo
Zondag
日曜日

WEEK 24

2006 JUNE JUNI JUIN JUNIO GIUGNO JUNHO JUNI 6月

MAY 2006

Monday	24	1	8	15	22	29
Tuesday	25	2	9	16	23	30
Wednesday	26	3	10	17	24	31
Thursday	27	4	11	18	25	1
Friday	28	5	12	19	26	2
Saturday	29	6	13	20	27	3
Sunday	30	7	14	21	28	4
Week	17	18	19	20	21	22

JUNE 2006

Monday	29	5	12	19	26
Tuesday	30	6	13	20	27
Wednesday	31	7	14	21	28
Thursday	1	8	15	22	29
Friday	2	9	16	23	30
Saturday	3	10	17	24	1
Sunday	4	11	18	25	2
Week	22	23	24	25	26

JULY 2006

Monday	26	3	10	17	24	31
Tuesday	27	4	11	18	25	1
Wednesday	28	5	12	19	26	2
Thursday	29	6	13	20	27	3
Friday	30	7	14	21	28	4
Saturday	1	8	15	22	29	5
Sunday	2	9	16	23	30	6
Week	26	27	28	29	30	31

19
Monday
Montag
Lundi
Lunes
Lunedì
Segunda-feira
Maandag
月曜日

20
Tuesday
Dienstag
Mardi
Martes
Martedì
Terça-feira
Dinsdag
火曜日

21
Wednesday
Mittwoch
Mercredi
Miércoles
Mercoledì
Quarta-feira
Woensdag
水曜日

22
Thursday
Donnerstag
Jeudi
Jueves
Giovedì
Quinta-feira
Donderdag
木曜日

23
Friday
Freitag
Vendredi
Viernes
Venerdì
Sexta-feira
Vrijdag
金曜日

24
Saturday
Samstag
Samedi
Sábado
Sabato
Sábado
Zaterdag
土曜日

25
Sunday
Sonntag
Dimanche
Domingo
Domenica
Domingo
Zondag
日曜日

WEEK 25

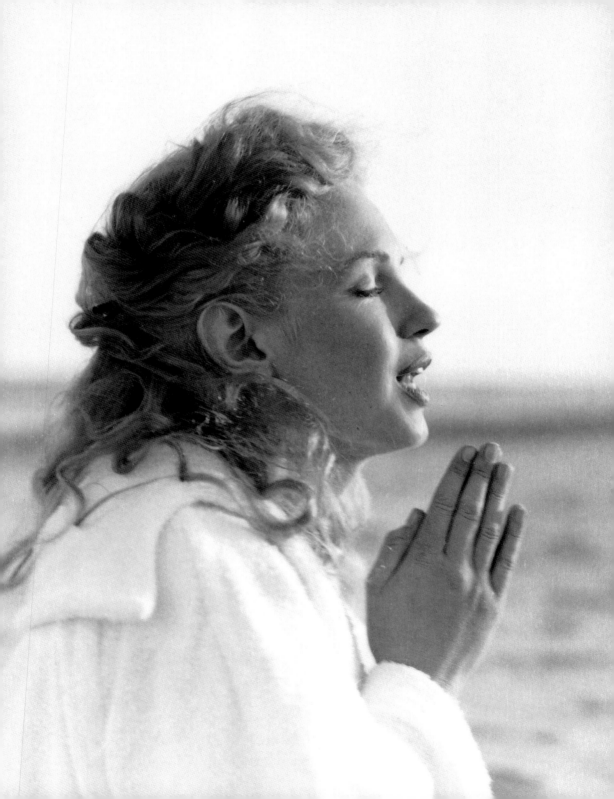

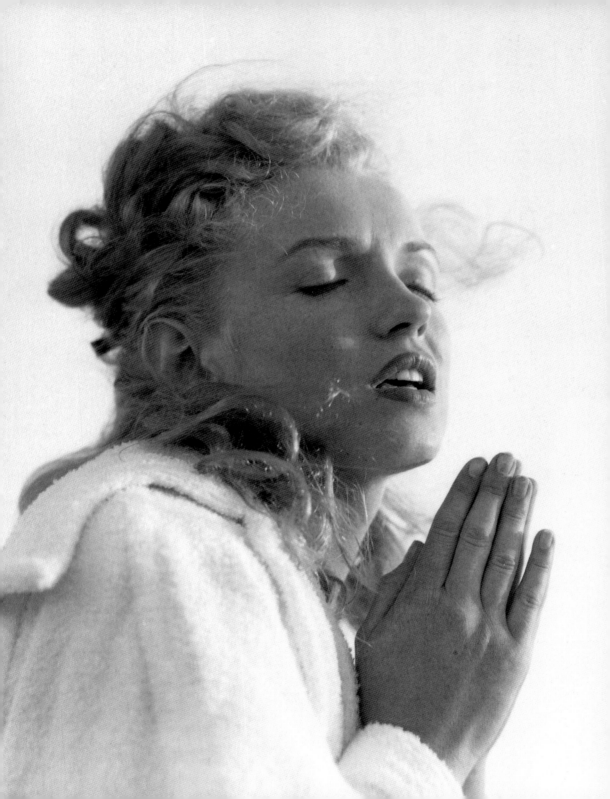

2006 JULY JULI JUILLET JULIO LUGLIO JULHO JULI 7月

JUNE 2006					
Monday	29	5	12	19	26
Tuesday	30	6	13	20	27
Wednesday	31	7	14	21	28
Thursday	1	8	15	22	29
Friday	2	9	16	23	30
Saturday	3	10	17	24	1
Sunday	4	11	18	25	2
Week	22	23	24	25	26

JULY 2006						
Monday	26	3	10	17	24	31
Tuesday	27	4	11	18	25	1
Wednesday	28	5	12	19	26	2
Thursday	29	6	13	20	27	3
Friday	30	7	14	21	28	4
Saturday	1	8	15	22	29	5
Sunday	2	9	16	23	30	6
Week	26	27	28	29	30	31

AUGUST 2006					
Monday	31	7	14	21	28
Tuesday	1	8	15	22	29
Wednesday	2	9	16	23	30
Thursday	3	10	17	24	31
Friday	4	11	18	25	1
Saturday	5	12	19	26	2
Sunday	6	13	20	27	3
Week	31	32	33	34	35

26
Monday
Montag
Lundi
Lunes
Lunedì
Segunda-feira
Maandag
月曜日

27
Tuesday
Dienstag
Mardi
Martes
Martedì
Terça-feira
Dinsdag
火曜日

28
Wednesday
Mittwoch
Mercredi
Miércoles
Mercoledì
Quarta-feira
Woensdag
水曜日

29
Thursday
Donnerstag
Jeudi
Jueves
Giovedì
Quinta-feira
Donderdag
木曜日

30
Friday
Freitag
Vendredi
Viernes
Venerdì
Sexta-feira
Vrijdag
金曜日

1
Saturday
Samstag
Samedi
Sábado
Sabato
Sábado
Zaterdag
土曜日

CDN Canada Day | Fête du Canada

2
Sunday
Sonntag
Dimanche
Domingo
Domenica
Domingo
Zondag
日曜日

WEEK 26

2006 JULY JULI JUILLET JULIO LUGLIO JULHO JULI 7月

JUNE 2006					
Monday	29	5	12	19	26
Tuesday	30	6	13	20	27
Wednesday	31	7	14	21	28
Thursday	1	8	15	22	29
Friday	2	9	16	23	30
Saturday	3	10	17	24	
Sunday	4	11	18	25	2
Week	22	23	24	25	26

JULY 2006						
Monday	26	3	10	17	24	31
Tuesday	27	4	11	18	25	1
Wednesday	28	5	12	19	26	2
Thursday	29	6	13	20	27	3
Friday	30	7	14	21	28	4
Saturday	1	8	15	22	29	5
Sunday	2	9	16	23	30	6
Week	26	27	28	29	30	31

AUGUST 2006					
Monday	31	7	14	21	28
Tuesday	1	8	15	22	29
Wednesday	2	9	16	23	30
Thursday	3	10	17	24	31
Friday	4	11	18	25	1
Saturday	5	12	19	26	2
Sunday	6	13	20	27	3
Week	31	32	33	34	35

3 Monday / Montag / Lundi / Lunes / Lunedì / Segunda-feira / Maandag / 月曜日

4 Tuesday / Dienstag / Mardi / Martes / Martedì / Terça-feira / Dinsdag / 火曜日 — (USA) Independence Day

5 Wednesday / Mittwoch / Mercredi / Miércoles / Mercoledì / Quarta-feira / Woensdag / 水曜日

6 Thursday / Donnerstag / Jeudi / Jueves / Giovedì / Quinta-feira / Donderdag / 木曜日

7 Friday / Freitag / Vendredi / Viernes / Venerdì / Sexta-feira / Vrijdag / 金曜日

8 Saturday / Samstag / Samedi / Sábado / Sabato / Sábado / Zaterdag / 土曜日

9 Sunday / Sonntag / Dimanche / Domingo / Domenica / Domingo / Zondag / 日曜日

WEEK 27

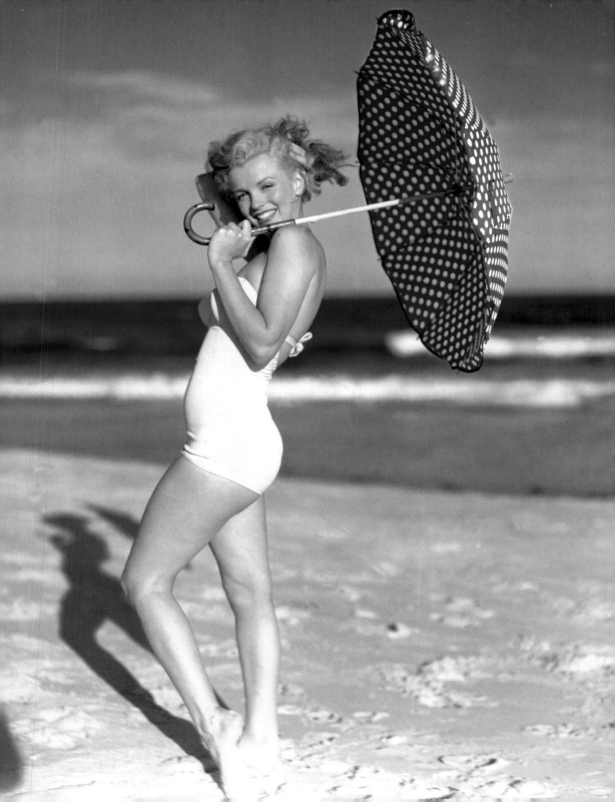

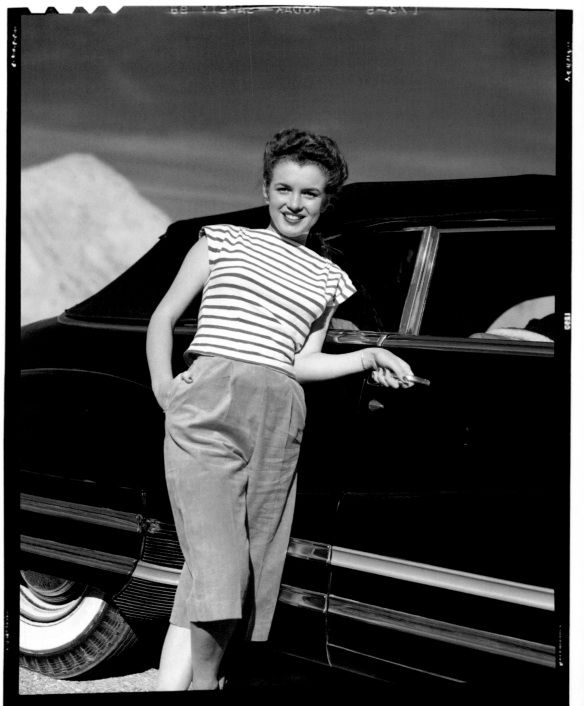

2006 JULY JULI JUILLET JULIO LUGLIO JULHO JULI 7月

JUNE 2006					
Monday	29	5	12	19	26
Tuesday	30	6	13	20	27
Wednesday	31	7	14	21	28
Thursday	1	8	15	22	29
Friday	2	9	16	23	30
Saturday	3	10	17	24	1
Sunday	4	11	18	25	2
Week	22	23	24	25	26

JULY 2006						
Monday	26	3	10	17	24	31
Tuesday	27	4	11	18	25	1
Wednesday	28	5	12	19	26	2
Thursday	29	6	13	20	27	3
Friday	30	7	14	21	28	4
Saturday	1	8	15	22	29	5
Sunday	2	9	16	23	30	6
Week	26	27	28	29	30	31

AUGUST 2006					
Monday	31	7	14	21	28
Tuesday	1	8	15	22	29
Wednesday	2	9	16	23	30
Thursday	3	10	17	24	31
Friday	4	11	18	25	1
Saturday	5	12	19	26	2
Sunday	6	13	20	27	3
Week	31	32	33	34	35

10
Monday
Montag
Lundi
Lunes
Lunedì
Segunda-feira
Maandag
月曜日

11
○
Tuesday
Dienstag
Mardi
Martes
Martedì
Terça-feira
Dinsdag
火曜日

12
Wednesday
Mittwoch
Mercredi
Miércoles
Mercoledì
Quarta-feira
Woensdag
水曜日

(UK) Battle of the Boyne Day
(Northern Ireland only)

13
Thursday
Donnerstag
Jeudi
Jueves
Giovedì
Quinta-feira
Donderdag
木曜日

14
Friday
Freitag
Vendredi
Viernes
Venerdì
Sexta-feira
Vrijdag
金曜日

(F) Fête Nationale

15
Saturday
Samstag
Samedi
Sábado
Sabato
Sábado
Zaterdag
土曜日

16
Sunday
Sonntag
Dimanche
Domingo
Domenica
Domingo
Zondag
日曜日

WEEK 28

2006 JULY JULI JUILLET JULIO LUGLIO JULHO JULI 7月

JUNE 2006					
Monday	29	5	12	19	26
Tuesday	30	6	13	20	27
Wednesday	31	7	14	21	28
Thursday	1	8	15	22	29
Friday	2	9	16	23	30
Saturday	3	10	17	24	1
Sunday	4	11	18	25	2
Week	22	23	24	25	26

JULY 2006						
Monday	26	3	10	17	24	31
Tuesday	27	4	11	18	25	1
Wednesday	28	5	12	19	26	2
Thursday	29	6	13	20	27	3
Friday	30	7	14	21	28	4
Saturday	1	8	15	22	29	5
Sunday	2	9	16	23	30	6
Week	26	27	28	29	30	31

AUGUST 2006					
Monday	31	7	14	21	28
Tuesday	1	8	15	22	29
Wednesday	2	9	16	23	30
Thursday	3	10	17	24	31
Friday	4	11	18	25	1
Saturday	5	12	19	26	2
Sunday	6	13	20	27	3
Week	31	32	33	34	35

17 Monday / Montag / Lundi / Lunes / Lunedì / Segunda-feira / Maandag / 月曜日

(J) Marine Day
(JOR) Constitution Day

18 Tuesday / Dienstag / Mardi / Martes / Martedì / Terça-feira / Dinsdag / 火曜日

19 Wednesday / Mittwoch / Mercredi / Miércoles / Mercoledì / Quarta-feira / Woensdag / 水曜日

20 Thursday / Donnerstag / Jeudi / Jueves / Giovedì / Quinta-feira / Donderdag / 木曜日

21 Friday / Freitag / Vendredi / Viernes / Venerdì / Sexta-feira / Vrijdag / 金曜日

22 Saturday / Samstag / Samedi / Sábado / Sabato / Sábado / Zaterdag / 土曜日

23 Sunday / Sonntag / Dimanche / Domingo / Domenica / Domingo / Zondag / 日曜日

WEEK 29

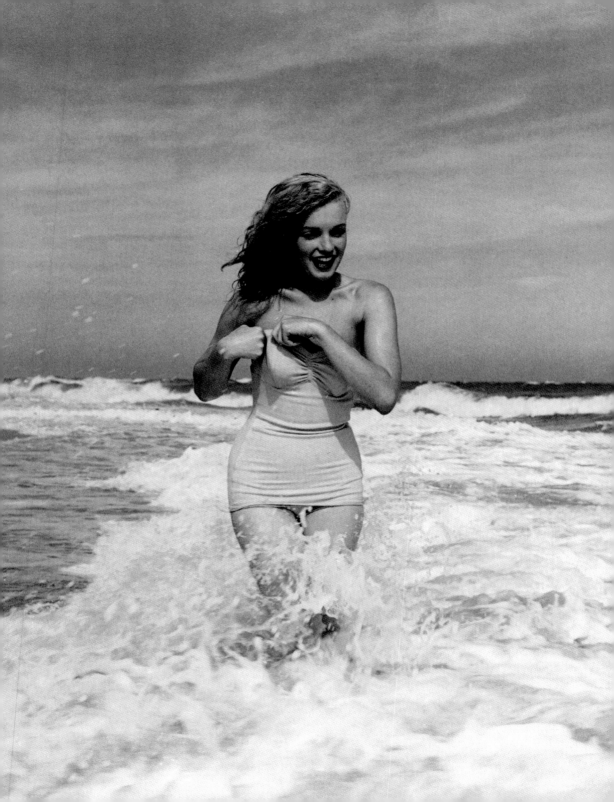

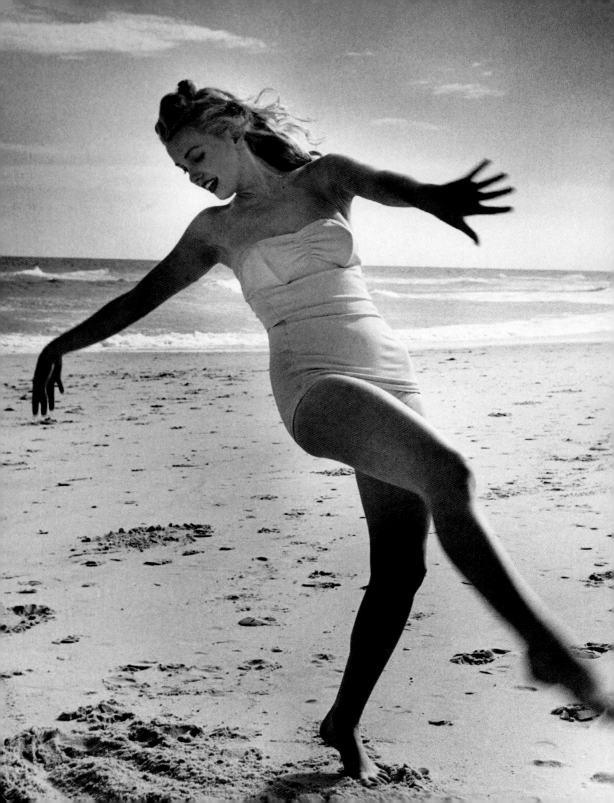

2006 JULY JULI JUILLET JULIO LUGLIO JULHO JULI 7月

JUNE 2006					
Monday	29	5	12	19	26
Tuesday	30	6	13	20	27
Wednesday	31	7	14	21	28
Thursday	1	8	15	22	29
Friday	2	9	16	23	30
Saturday	3	10	17	24	1
Sunday	4	11	18	25	2
Week	22	23	24	25	26

JULY 2006						
Monday	26	3	10	17	24	31
Tuesday	27	4	11	18	25	1
Wednesday	28	5	12	19	26	2
Thursday	29	6	13	20	27	3
Friday	30	7	14	21	28	4
Saturday	1	8	15	22	29	5
Sunday	2	9	16	23	30	6
Week	26	27	28	29	30	31

AUGUST 2006					
Monday	31	7	14	21	28
Tuesday	1	8	15	22	29
Wednesday	2	9	16	23	30
Thursday	3	10	17	24	31
Friday	4	11	18	25	1
Saturday	5	12	19	26	2
Sunday	6	13	20	27	3
Week	31	32	33	34	35

24
Monday
Montag
Lundi
Lunes
Lunedì
Segunda-feira
Maandag
月曜日

25
Tuesday
Dienstag
Mardi
Martes
Martedì
Terça-feira
Dinsdag
火曜日

26
Wednesday
Mittwoch
Mercredi
Miércoles
Mercoledì
Quarta-feira
Woensdag
水曜日

27
Thursday
Donnerstag
Jeudi
Jueves
Giovedì
Quinta-feira
Donderdag
木曜日

28
Friday
Freitag
Vendredi
Viernes
Venerdì
Sexta-feira
Vrijdag
金曜日

29
Saturday
Samstag
Samedi
Sábado
Sabato
Sábado
Zaterdag
土曜日

30
Sunday
Sonntag
Dimanche
Domingo
Domenica
Domingo
Zondag
日曜日

WEEK 30

2006 AUGUST AUGUST AOÛT AUGUSTO AGOSTO AGOSTO AUGUSTUS 8月

JULY 2006							AUGUST 2006						SEPTEMBER 2006					
Monday	26	3	10	17	24	31	Monday	31	7	14	21	28	Monday	28	4	11	18	25
Tuesday	27	4	11	18	25	1	Tuesday	1	8	15	22	29	Tuesday	29	5	12	19	26
Wednesday	28	5	12	19	26	2	Wednesday	2	9	16	23	30	Wednesday	30	6	13	20	27
Thursday	29	6	13	20	27	3	Thursday	3	10	17	24	31	Thursday	31	7	14	21	28
Friday	30	7	14	21	28	4	Friday	4	11	18	25	1	Friday	1	8	15	22	29
Saturday	1	8	15	22	29	5	Saturday	5	12	19	26	2	Saturday	2	9	16	23	30
Sunday	2	9	16	23	30	6	Sunday	6	13	20	27	3	Sunday	3	10	17	24	1
Week	26	27	28	29	30	31	Week	31	32	33	34	35	Week	35	36	37	38	39

31
Monday
Montag
Lundi
Lunes
Lunedì
Segunda-feira
Maandag
月曜日

1
Tuesday
Dienstag
Mardi
Martes
Martedì
Terça-feira
Dinsdag
火曜日

CH Bundesfeiertag | Fête nationale | Festa nazionale

2
Wednesday
Mittwoch
Mercredi
Miércoles
Mercoledì
Quarta-feira
Woensdag
水曜日

3
Thursday
Donnerstag
Jeudi
Jueves
Giovedì
Quinta-feira
Donderdag
木曜日

IL Tisha B'Av

4
Friday
Freitag
Vendredi
Viernes
Venerdì
Sexta-feira
Vrijdag
金曜日

5
Saturday
Samstag
Samedi
Sábado
Sabato
Sábado
Zaterdag
土曜日

6
Sunday
Sonntag
Dimanche
Domingo
Domenica
Domingo
Zondag
日曜日

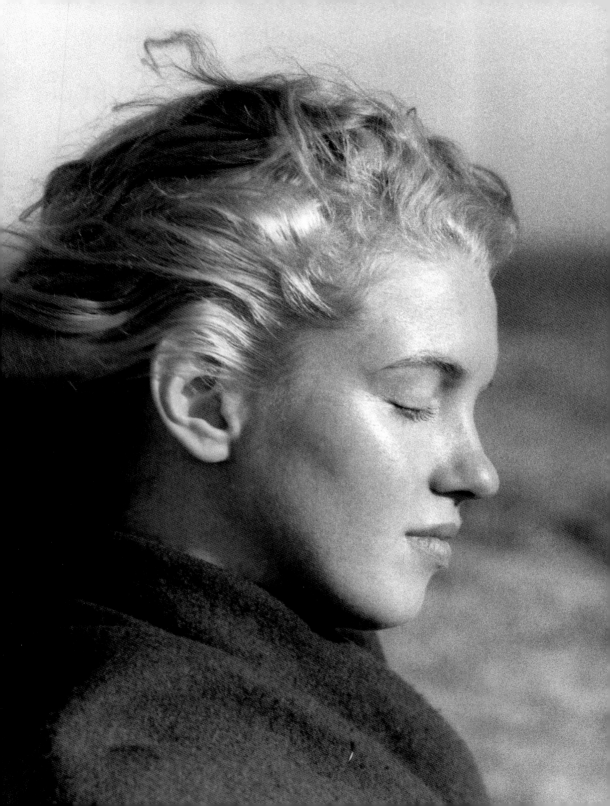

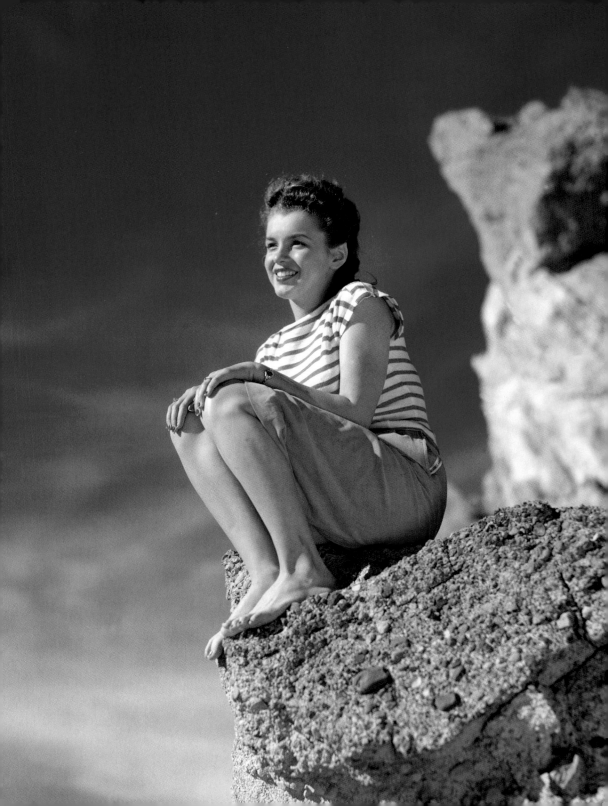

2006 AUGUST AUGUST AOÛT AUGUSTO AGOSTO AGOSTO AUGUSTUS 8月

JULY 2006						
Monday	26	3	10	17	24	31
Tuesday	27	4	11	18	25	1
Wednesday	28	5	12	19	26	2
Thursday	29	6	13	20	27	3
Friday	30	7	14	21	28	4
Saturday	1	8	15	22	29	5
Sunday	2	9	16	23	30	6
Week	26	27	28	29	30	31

AUGUST 2006					
Monday	31	7	14	21	28
Tuesday	1	8	15	22	29
Wednesday	2	9	16	23	30
Thursday	3	10	17	24	31
Friday	4	11	18	25	1
Saturday	5	12	19	26	2
Sunday	6	13	20	27	3
Week	31	32	33	34	35

SEPTEMBER 2006					
Monday	28	4	11	18	25
Tuesday	29	5	12	19	26
Wednesday	30	6	13	20	27
Thursday	31	7	14	21	28
Friday	1	8	15	22	29
Saturday	2	9	16	23	30
Sunday	3	10	17	24	1
Week	35	36	37	38	39

7
Monday
Montag
Lundi
Lunes
Lunedì
Segunda-feira
Maandag
月曜日

(UK) Summer Bank Holiday
(Scotland only)
(IRL) First Monday in August

8
Tuesday
Dienstag
Mardi
Martes
Martedì
Terça-feira
Dinsdag
火曜日

○ **9**
Wednesday
Mittwoch
Mercredi
Miércoles
Mercoledì
Quarta-feira
Woensdag
水曜日

10
Thursday
Donnerstag
Jeudi
Jueves
Giovedì
Quinta-feira
Donderdag
木曜日

11
Friday
Freitag
Vendredi
Viernes
Venerdì
Sexta-feira
Vrijdag
金曜日

12
Saturday
Samstag
Samedi
Sábado
Sabato
Sábado
Zaterdag
土曜日

13
Sunday
Sonntag
Dimanche
Domingo
Domenica
Domingo
Zondag
日曜日

WEEK 32

2006 AUGUST

AUGUST AOÛT AUGUSTO AGOSTO AGOSTO AUGUSTUS 8月

JULY 2006						
Monday	26	3	10	17	24	31
Tuesday	27	4	11	18	25	1
Wednesday	28	5	12	19	26	2
Thursday	29	6	13	20	27	3
Friday	30	7	14	21	28	4
Saturday	1	8	15	22	29	5
Sunday	2	9	16	23	30	6
Week	26	27	28	29	30	31

AUGUST 2006					
Monday	31	7	14	21	28
Tuesday	1	8	15	22	29
Wednesday	2	9	16	23	30
Thursday	3	10	17	24	31
Friday	4	11	18	25	1
Saturday	5	12	19	26	2
Sunday	6	13	20	27	3
Week	31	32	33	34	35

SEPTEMBER 2006					
Monday	28	4	11	18	25
Tuesday	29	5	12	19	26
Wednesday	30	6	13	20	27
Thursday	31	7	14	21	28
Friday	1	8	15	22	29
Saturday	2	9	16	23	30
Sunday	3	10	17	24	1
Week	35	36	37	38	39

14
Monday
Montag
Lundi
Lunes
Lunedì
Segunda-feira
Maandag
月曜日

15
Tuesday
Dienstag
Mardi
Martes
Martedì
Terça-feira
Dinsdag
火曜日

(D) Mariä Himmelfahrt (teilweise)
(F) (A) (E) (I) (P)
Assomption | Mariä Himmelfahrt |
Asunción de la Virgen | Assunzione |
Assunção de Nossa Senhora
(ROK) Independence Day

16
Wednesday
Mittwoch
Mercredi
Miércoles
Mercoledì
Quarta-feira
Woensdag
水曜日

17
Thursday
Donnerstag
Jeudi
Jueves
Giovedì
Quinta-feira
Donderdag
木曜日

18
Friday
Freitag
Vendredi
Viernes
Venerdì
Sexta-feira
Vrijdag
金曜日

19
Saturday
Samstag
Samedi
Sábado
Sabato
Sábado
Zaterdag
土曜日

20
Sunday
Sonntag
Dimanche
Domingo
Domenica
Domingo
Zondag
日曜日

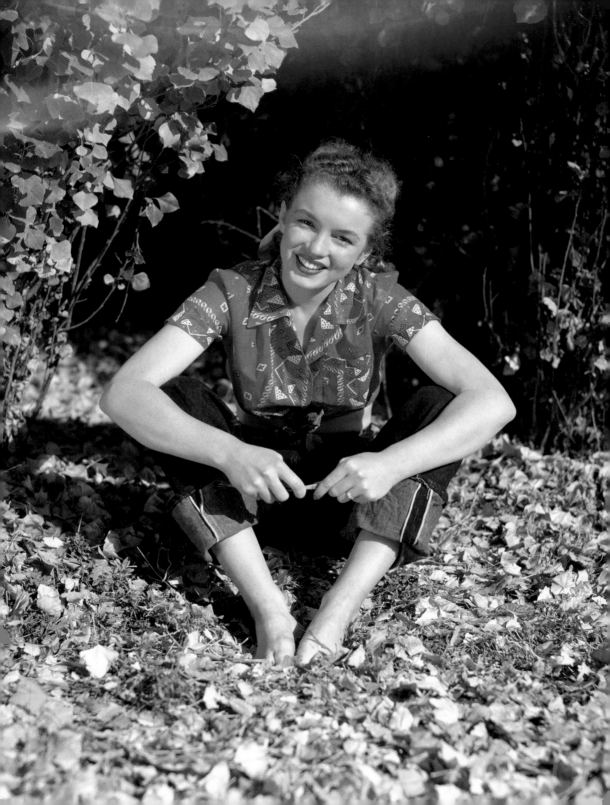

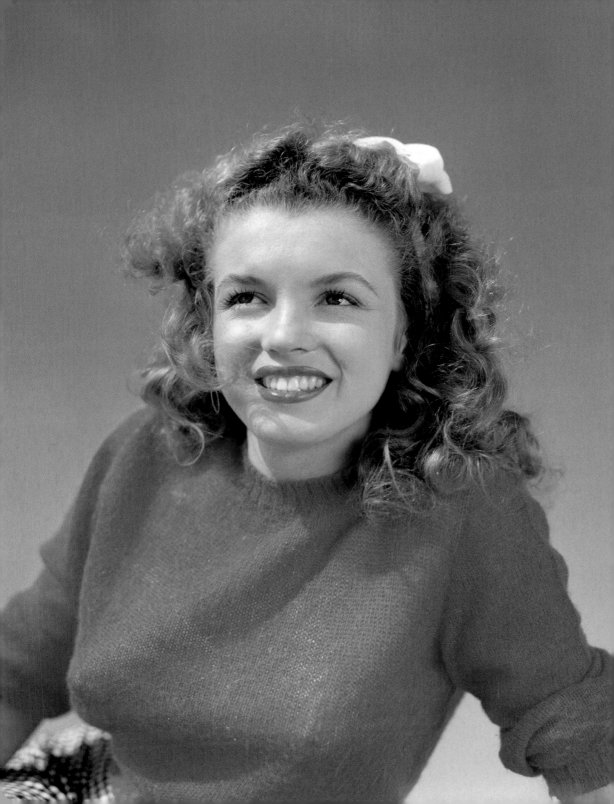

JULY 2006							AUGUST 2006						SEPTEMBER 2006					
Monday	26	3	10	17	24	31	Monday	31	7	14	21	28	Monday	28	4	11	18	25
Tuesday	27	4	11	18	25	1	Tuesday	1	8	15	22	29	Tuesday	29	5	12	19	26
Wednesday	28	5	12	19	26	2	Wednesday	2	9	16	23	30	Wednesday	30	6	13	20	27
Thursday	29	6	13	20	27	3	Thursday	3	10	17	24	31	Thursday	31	7	14	21	28
Friday	30	7	14	21	28	4	Friday	4	11	18	25	1	Friday	1	8	15	22	29
Saturday	1	8	15	22	29	5	Saturday	5	12	19	26	2	Saturday	2	9	16	23	30
Sunday	2	9	16	23	30	6	Sunday	6	13	20	27	3	Sunday	3	10	17	24	1
Week	26	27	28	29	30	31	Week	31	32	33	34	35	Week	35	36	37	38	39

21
Monday
Montag
Lundi
Lunes
Lunedì
Segunda-feira
Maandag
月曜日

22
Tuesday
Dienstag
Mardi
Martes
Martedì
Terça-feira
Dinsdag
火曜日

23
● Wednesday
Mittwoch
Mercredi
Miércoles
Mercoledì
Quarta-feira
Woensdag
水曜日

24
Thursday
Donnerstag
Jeudi
Jueves
Giovedì
Quinta-feira
Donderdag
木曜日

25
Friday
Freitag
Vendredi
Viernes
Venerdì
Sexta-feira
Vrijdag
金曜日

26
Saturday
Samstag
Samedi
Sábado
Sabato
Sábado
Zaterdag
土曜日

27
Sunday
Sonntag
Dimanche
Domingo
Domenica
Domingo
Zondag
日曜日

WEEK 34

2006 SEPTEMBER

AUGUST 2006

Monday	31	7	14	21	28
Tuesday	1	8	15	22	29
Wednesday	2	9	16	23	30
Thursday	3	10	17	24	31
Friday	4	11	18	25	1
Saturday	5	12	19	26	2
Sunday	6	13	20	27	3
Week	31	32	33	34	35

SEPTEMBER 2006

Monday	28	4	11	18	25
Tuesday	29	5	12	19	26
Wednesday	30	6	13	20	27
Thursday	31	7	14	21	28
Friday	1	8	15	22	29
Saturday	2	9	16	23	30
Sunday	3	10	17	24	1
Week	35	36	37	38	39

OCTOBER 2006

Monday	25	2	9	16	23	30
Tuesday	26	3	10	17	24	31
Wednesday	27	4	11	18	25	1
Thursday	28	5	12	19	26	2
Friday	29	6	13	20	27	3
Saturday	30	7	14	21	28	4
Sunday	1	8	15	22	29	5
Week	39	40	41	42	43	44

28
Monday
Montag
Lundi
Lunes
Lunedì
Segunda-feira
Maandag
月曜日

(UK) Summer Bank Holiday
(except Scotland)

29
Tuesday
Dienstag
Mardi
Martes
Martedì
Terça-feira
Dinsdag
火曜日

30
Wednesday
Mittwoch
Mercredi
Miércoles
Mercoledì
Quarta-feira
Woensdag
水曜日

31
Thursday
Donnerstag
Jeudi
Jueves
Giovedì
Quinta-feira
Donderdag
木曜日

1
Friday
Freitag
Vendredi
Viernes
Venerdì
Sexta-feira
Vrijdag
金曜日

2
Saturday
Samstag
Samedi
Sábado
Sabato
Sábado
Zaterdag
土曜日

3
Sunday
Sonntag
Dimanche
Domingo
Domenica
Domingo
Zondag
日曜日

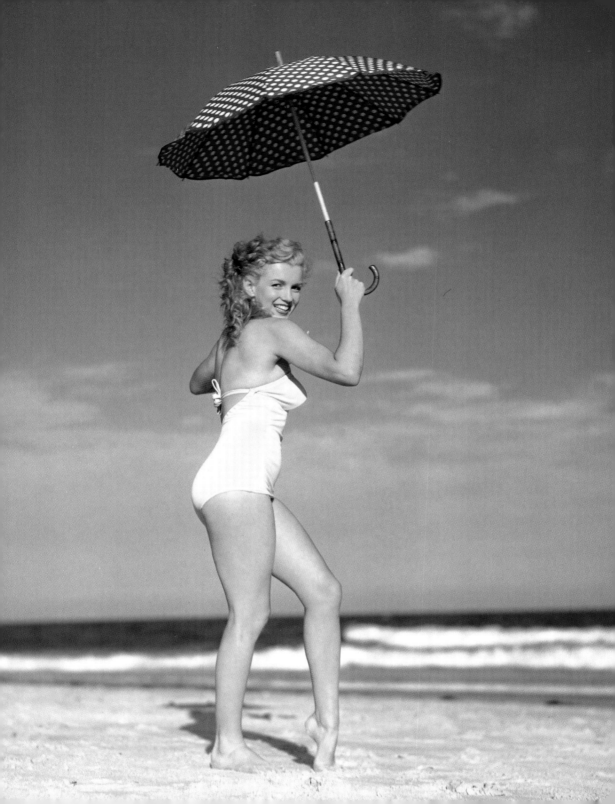

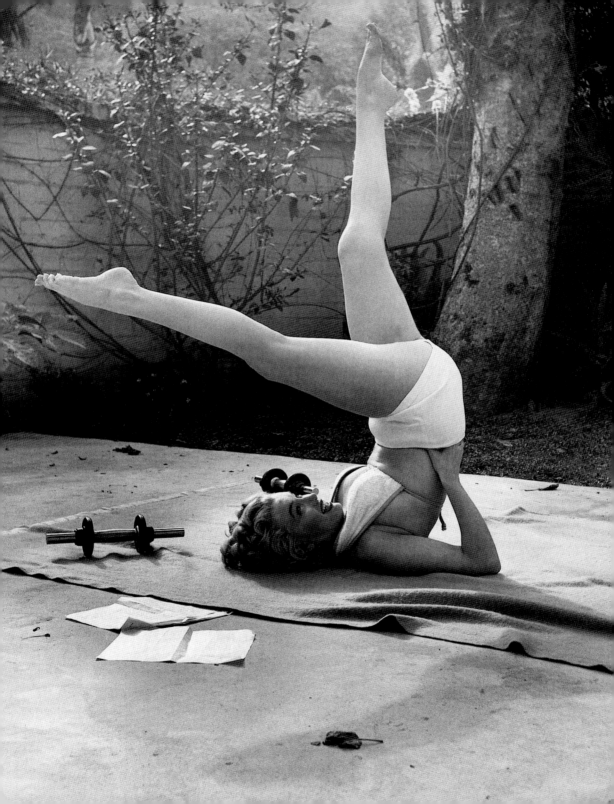

2006 SEPTEMBER SEPTEMBER SEPTEMBRE SEPTIEMBRE SETTEMBRE SEPTEMBRO SEPTEMBER 9月

AUGUST 2006					
Monday	31	7	14	21	28
Tuesday	1	8	15	22	29
Wednesday	2	9	16	23	30
Thursday	3	10	17	24	31
Friday	4	11	18	25	1
Saturday	5	12	19	26	2
Sunday	6	13	20	27	3
Week	31	32	33	34	35

SEPTEMBER 2006					
Monday	28	4	11	18	25
Tuesday	29	5	12	19	26
Wednesday	30	6	13	20	27
Thursday	31	7	14	21	28
Friday	1	8	15	22	29
Saturday	2	9	16	23	30
Sunday	3	10	17	24	1
Week	35	36	37	38	39

OCTOBER 2006						
Monday	25	2	9	16	23	30
Tuesday	26	3	10	17	24	31
Wednesday	27	4	11	18	25	1
Thursday	28	5	12	19	26	2
Friday	29	6	13	20	27	3
Saturday	30	7	14	21	28	4
Sunday	1	8	15	22	29	5
Week	39	40	41	42	43	44

4 Monday / Montag / Lundi / Lunes / Lunedì / Segunda-feira / Maandag / 月曜日 — (USA) Labor Day; (CDN) Labour Day | Fête du Travail

5 Tuesday / Dienstag / Mardi / Martes / Martedì / Terça-feira / Dinsdag / 火曜日

6 Wednesday / Mittwoch / Mercredi / Miércoles / Mercoledì / Quarta-feira / Woensdag / 水曜日

7 Thursday / Donnerstag / Jeudi / Jueves / Giovedì / Quinta-feira / Donderdag / 木曜日

8 Friday / Freitag / Vendredi / Viernes / Venerdì / Sexta-feira / Vrijdag / 金曜日

9 Saturday / Samstag / Samedi / Sábado / Sabato / Sábado / Zaterdag / 土曜日

10 Sunday / Sonntag / Dimanche / Domingo / Domenica / Domingo / Zondag / 日曜日

WEEK 36

2006 SEPTEMBER

SEPTEMBER SEPTEMBRE SEPTIEMBRE SETTEMBRE SEPTEMBRO SEPTEMBER 9月

AUGUST 2006					
Monday	31	7	14	21	28
Tuesday	1	8	15	22	29
Wednesday	2	9	16	23	30
Thursday	3	10	17	24	31
Friday	4	11	18	25	1
Saturday	5	12	19	26	2
Sunday	6	13	20	27	3
Week	31	32	33	34	35

SEPTEMBER 2006					
Monday	28	4	11	18	25
Tuesday	29	5	12	19	26
Wednesday	30	6	13	20	27
Thursday	31	7	14	21	28
Friday	1	8	15	22	29
Saturday	2	9	16	23	30
Sunday	3	10	17	24	1
Week	35	36	37	38	39

OCTOBER 2006							
Monday	25	2	9	16	23	30	
Tuesday	26	3	10	17	24	31	
Wednesday	27	4	11	18	25	1	
Thursday	28	5	12	19	26	2	
Friday	29	6	13	20	27	3	
Saturday	30	7	14	21	28	4	
Sunday		1	8	15	22	29	5
Week	39	40	41	42	43	44	

11
Monday
Montag
Lundi
Lunes
Lunedì
Segunda-feira
Maandag
月曜日

12
Tuesday
Dienstag
Mardi
Martes
Martedì
Terça-feira
Dinsdag
火曜日

13
Wednesday
Mittwoch
Mercredi
Miércoles
Mercoledì
Quarta-feira
Woensdag
水曜日

14
Thursday
Donnerstag
Jeudi
Jueves
Giovedì
Quinta-feira
Donderdag
木曜日

15
Friday
Freitag
Vendredi
Viernes
Venerdì
Sexta-feira
Vrijdag
金曜日

16
Saturday
Samstag
Samedi
Sábado
Sabato
Sábado
Zaterdag
土曜日

17
Sunday
Sonntag
Dimanche
Domingo
Domenica
Domingo
Zondag
日曜日

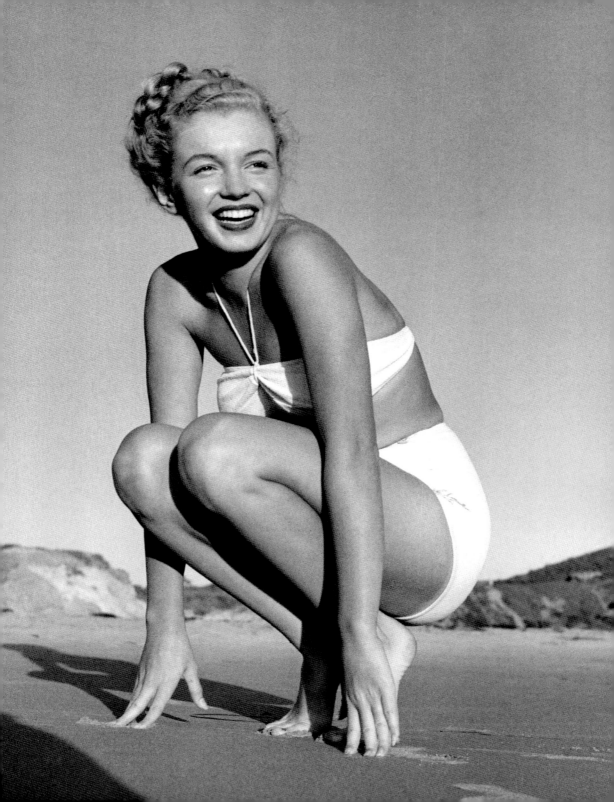

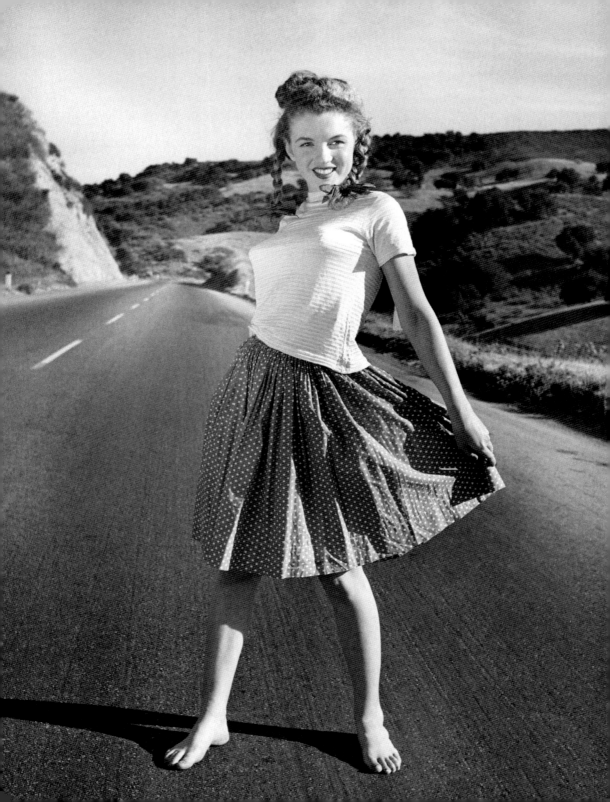

2006 SEPTEMBER

SEPTEMBER SEPTEMBRE SEPTIEMBRE SETTEMBRE SEPTEMBRO SEPTEMBER 9月

AUGUST 2006

Monday	31	7	14	21	28
Tuesday	1	8	15	22	29
Wednesday	2	9	16	23	30
Thursday	3	10	17	24	31
Friday	4	11	18	25	1
Saturday	5	12	19	26	2
Sunday	6	13	20	27	3
Week	31	32	33	34	35

SEPTEMBER 2006

Monday	28	4	11	18	25
Tuesday	29	5	12	19	26
Wednesday	30	6	13	20	27
Thursday	31	7	14	21	28
Friday	1	8	15	22	29
Saturday	2	9	16	23	30
Sunday	3	10	17	24	1
Week	35	36	37	38	39

OCTOBER 2006

Monday	25	2	9	16	23	30
Tuesday	26	3	10	17	24	31
Wednesday	27	4	11	18	25	1
Thursday	28	5	12	19	26	2
Friday	29	6	13	20	27	3
Saturday	30	7	14	21	28	4
Sunday	1	8	15	22	29	5
Week	39	40	41	42	43	44

18
Monday
Montag
Lundi
Lunes
Lunedì
Segunda-feira
Maandag
月曜日

19
Tuesday
Dienstag
Mardi
Martes
Martedì
Terça-feira
Dinsdag
火曜日

20
Wednesday
Mittwoch
Mercredi
Miércoles
Mercoledì
Quarta-feira
Woensdag
水曜日

21
Thursday
Donnerstag
Jeudi
Jueves
Giovedì
Quinta-feira
Donderdag
木曜日

● **22**
Friday
Freitag
Vendredi
Viernes
Venerdì
Sexta-feira
Vrijdag
金曜日

23
Saturday
Samstag
Samedi
Sábado
Sabato
Sábado
Zaterdag
土曜日

(J) Autumn Equinox Day
(IL) Rosh Hashanah

24
Sunday
Sonntag
Dimanche
Domingo
Domenica
Domingo
Zondag
日曜日

(IL) Rosh Hashanah

WEEK 38

2006 OCTOBER OKTOBER OCTOBRE OCTUBRE OTTOBRE OUTUBRO OKTOBER 10月

SEPTEMBER 2006

Monday	28	4	11	18	25
Tuesday	29	5	12	19	26
Wednesday	30	6	13	20	27
Thursday	31	7	14	21	28
Friday	1	8	15	22	29
Saturday	2	9	16	23	30
Sunday	3	10	17	24	1
Week	35	36	37	38	39

OCTOBER 2006

Monday	25	2	9	16	23	30
Tuesday	26	3	10	17	24	31
Wednesday	27	4	11	18	25	1
Thursday	28	5	12	19	26	2
Friday	29	6	13	20	27	3
Saturday	30	7	14	21	28	4
Sunday	1	8	15	22	29	5
Week	39	40	41	42	43	44

NOVEMBER 2006

Monday	30	6	13	20	27
Tuesday	31	7	14	21	28
Wednesday	1	8	15	22	29
Thursday	2	9	16	23	30
Friday	3	10	17	24	1
Saturday	4	11	18	25	2
Sunday	5	12	19	26	3
Week	44	45	46	47	48

25
Monday
Montag
Lundi
Lunes
Lunedì
Segunda-feira
Maandag
月曜日

26
Tuesday
Dienstag
Mardi
Martes
Martedì
Terça-feira
Dinsdag
火曜日

27
Wednesday
Mittwoch
Mercredi
Miércoles
Mercoledì
Quarta-feira
Woensdag
水曜日

28
Thursday
Donnerstag
Jeudi
Jueves
Giovedì
Quinta-feira
Donderdag
木曜日

29
Friday
Freitag
Vendredi
Viernes
Venerdì
Sexta-feira
Vrijdag
金曜日

30
Saturday
Samstag
Samedi
Sábado
Sabato
Sábado
Zaterdag
土曜日

1
Sunday
Sonntag
Dimanche
Domingo
Domenica
Domingo
Zondag
日曜日

WEEK 39

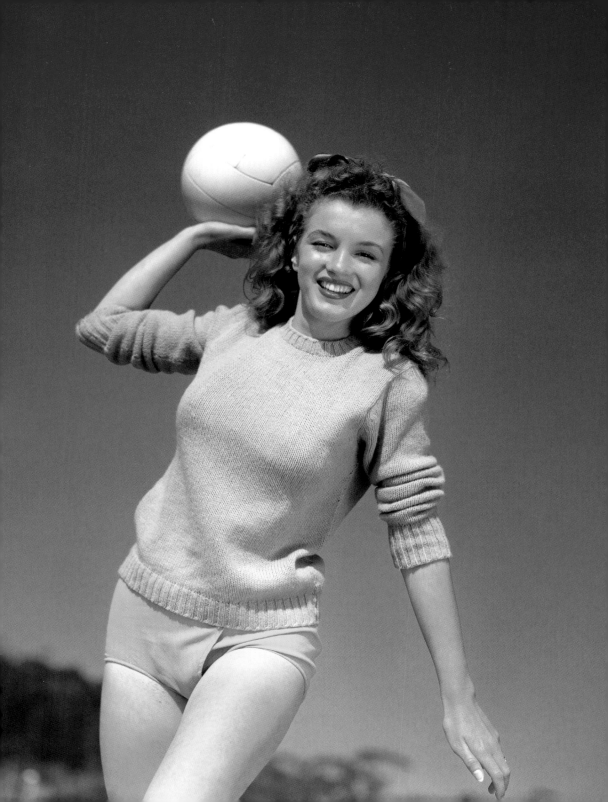

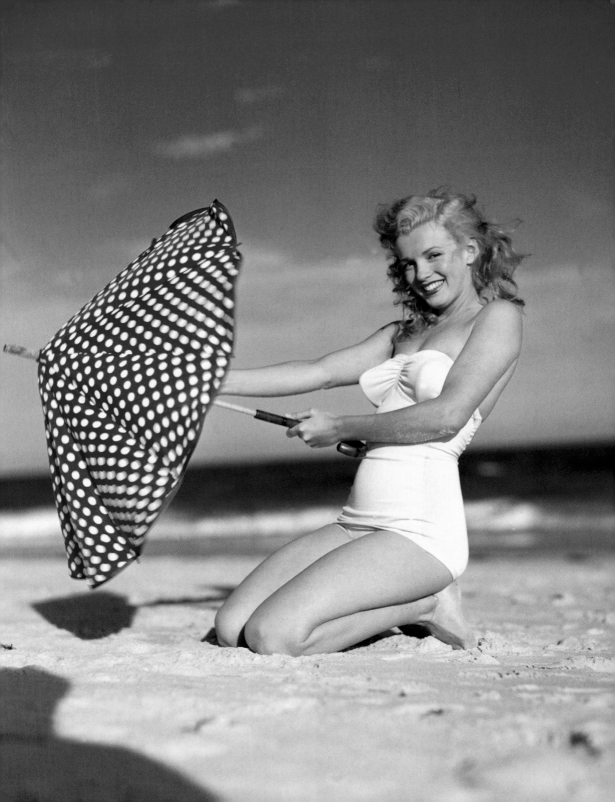

SEPTEMBER 2006					
Monday	28	4	11	18	25
Tuesday	29	5	12	19	26
Wednesday	30	6	13	20	27
Thursday	31	7	14	21	28
Friday	1	8	15	22	29
Saturday	2	9	16	23	30
Sunday	3	10	17	24	1
Week	35	36	37	38	39

OCTOBER 2006						
Monday	25	2	9	16	23	30
Tuesday	26	3	10	17	24	31
Wednesday	27	4	11	18	25	1
Thursday	28	5	12	19	26	2
Friday	29	6	13	20	27	3
Saturday	30	7	14	21	28	4
Sunday	1	8	15	22	29	5
Week	39	40	41	42	43	44

NOVEMBER 2006					
Monday	30	6	13	20	27
Tuesday	31	7	14	21	28
Wednesday	1	8	15	22	29
Thursday	2	9	16	23	30
Friday	3	10	17	24	1
Saturday	4	11	18	25	2
Sunday	5	12	19	26	3
Week	44	45	46	47	48

2
Monday ·
Montag
Lundi
Lunes
Lunedì
Segunda-feira
Maandag
月曜日

(IL) Yom Kippur

3
Tuesday
Dienstag
Mardi
Martes
Martedì
Terça-feira
Dinsdag
火曜日

(D) Tag der Deutschen Einheit
(ROK) National Foundation Day

4
Wednesday
Mittwoch
Mercredi
Miércoles
Mercoledì
Quarta-feira
Woensdag
水曜日

5
Thursday
Donnerstag
Jeudi
Jueves
Giovedì
Quinta-feira
Donderdag
木曜日

(P) Implantação da República

6
Friday
Freitag
Vendredi
Viernes
Venerdì
Sexta-feira
Vrijdag
金曜日

7
Saturday
Samstag
Samedi
Sábado
Sabato
Sábado
Zaterdag
土曜日

(IL) Succoth
(ROK) Chuseok

8
Sunday
Sonntag
Dimanche
Domingo
Domenica
Domingo
Zondag
日曜日

WEEK 40

2006 OCTOBER

OKTOBER OCTOBRE OCTUBRE OTTOBRE OUTUBRO OKTOBER 10月

SEPTEMBER 2006						OCTOBER 2006						NOVEMBER 2006						
Monday	28	4	11	18	25	Monday	25	2	9	16	23	30	Monday	30	6	13	20	27
Tuesday	29	5	12	19	26	Tuesday	26	3	10	17	24	31	Tuesday	31	7	14	21	28
Wednesday	30	6	13	20	27	Wednesday	27	4	11	18	25	1	Wednesday	1	8	15	22	29
Thursday	31	7	14	21	28	Thursday	28	5	12	19	26	2	Thursday	2	9	16	23	30
Friday	1	8	15	22	29	Friday	29	6	13	20	27	3	Friday	3	10	17	24	1
Saturday	2	9	16	23	30	Saturday	30	7	14	21	28	4	Saturday	4	11	18	25	2
Sunday	3	10	17	24	1	Sunday	1	8	15	22	29	5	Sunday	5	12	19	26	3
Week	35	36	37	38	39	Week	39	40	41	42	43	44	Week	44	45	46	47	48

9
Monday
Montag
Lundi
Lunes
Lunedì
Segunda-feira
Maandag
月曜日

(USA) Columbus Day
(CDN) Thanksgiving Day | Action de Grâces
(J) Health-Sports Day

10
Tuesday
Dienstag
Mardi
Martes
Martedì
Terça-feira
Dinsdag
火曜日

11
Wednesday
Mittwoch
Mercredi
Miércoles
Mercoledì
Quarta-feira
Woensdag
水曜日

12
Thursday
Donnerstag
Jeudi
Jueves
Giovedì
Quinta-feira
Donderdag
木曜日

(E) Fiesta Nacional

13
Friday
Freitag
Vendredi
Viernes
Venerdì
Sexta-feira
Vrijdag
金曜日

14
Saturday
Samstag
Samedi
Sábado
Sabato
Sábado
Zaterdag
土曜日

(IL) Sh'mini Atzereth
(IL) Simchat Torah

15
Sunday
Sonntag
Dimanche
Domingo
Domenica
Domingo
Zondag
日曜日

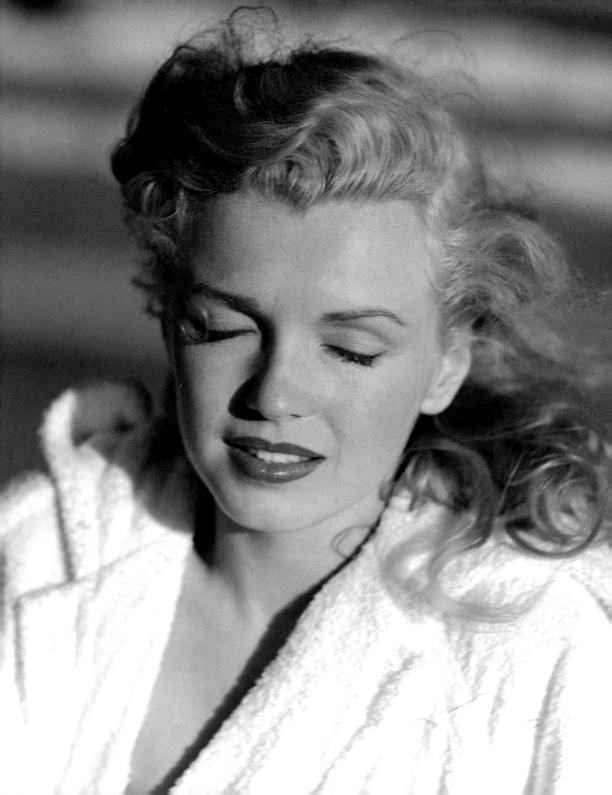

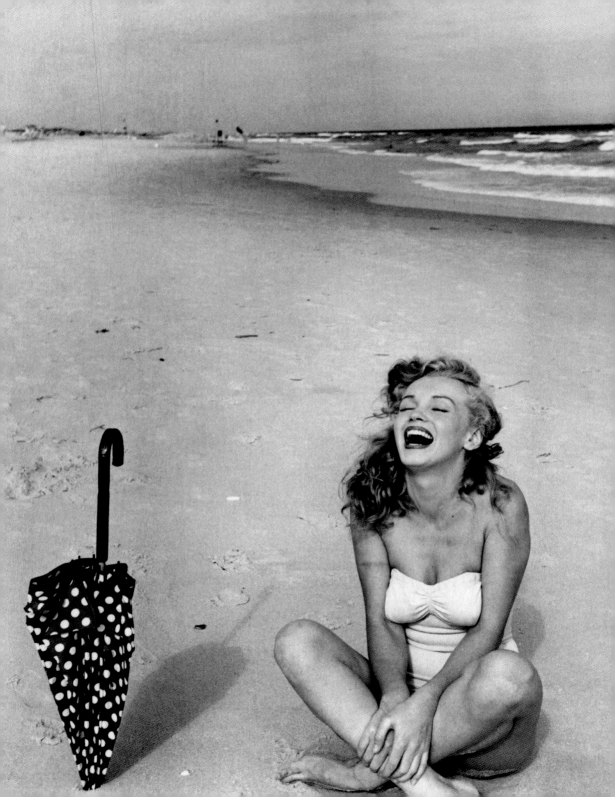

2006 OCTOBER OKTOBER OCTOBRE OCTUBRE OTTOBRE OUTUBRO OKTOBER 10月

SEPTEMBER 2006

Monday	28	4	11	18	25
Tuesday	29	5	12	19	26
Wednesday	30	6	13	20	27
Thursday	31	7	14	21	28
Friday	1	8	15	22	29
Saturday	2	9	16	23	30
Sunday	3	10	17	24	1
Week	35	36	37	38	39

OCTOBER 2006

Monday	25	2	9	16	23	30
Tuesday	26	3	10	17	24	31
Wednesday	27	4	11	18	25	1
Thursday	28	5	12	19	26	2
Friday	29	6	13	20	27	3
Saturday	30	7	14	21	28	4
Sunday	1	8	15	22	29	5
Week	39	40	41	42	43	44

NOVEMBER 2006

Monday	30	6	13	20	27
Tuesday	31	7	14	21	28
Wednesday	1	8	15	22	29
Thursday	2	9	16	23	30
Friday	3	10	17	24	1
Saturday	4	11	18	25	2
Sunday	5	12	19	26	3
Week	44	45	46	47	48

16
Monday
Montag
Lundi
Lunes
Lunedì
Segunda-feira
Maandag
月曜日

17
Tuesday
Dienstag
Mardi
Martes
Martedì
Terça-feira
Dinsdag
火曜日

18
Wednesday
Mittwoch
Mercredi
Miércoles
Mercoledì
Quarta-feira
Woensdag
水曜日

19
Thursday
Donnerstag
Jeudi
Jueves
Giovedì
Quinta-feira
Donderdag
木曜日

20
Friday
Freitag
Vendredi
Viernes
Venerdì
Sexta-feira
Vrijdag
金曜日

21
Saturday
Samstag
Samedi
Sábado
Sabato
Sábado
Zaterdag
土曜日

22
Sunday
Sonntag
Dimanche
Domingo
Domenica
Domingo
Zondag
日曜日

WEEK 42

2006 OCTOBER OKTOBER OCTOBRE OCTUBRE OTTOBRE OUTUBRO OKTOBER 10月

SEPTEMBER 2006					
Monday	28	4	11	18	25
Tuesday	29	5	12	19	26
Wednesday	30	6	13	20	27
Thursday	31	7	14	21	28
Friday	1	8	15	22	29
Saturday	2	9	16	23	30
Sunday	3	10	17	24	1
Week	35	36	37	38	39

OCTOBER 2006						
Monday	25	2	9	16	23	30
Tuesday	26	3	10	17	24	31
Wednesday	27	4	11	18	25	1
Thursday	28	5	12	19	26	2
Friday	29	6	13	20	27	3
Saturday	30	7	14	21	28	4
Sunday	1	8	15	22	29	5
Week	39	40	41	42	43	44

NOVEMBER 2006					
Monday	30	6	13	20	27
Tuesday	31	7	14	21	28
Wednesday	1	8	15	22	29
Thursday	2	9	16	23	30
Friday	3	10	17	24	1
Saturday	4	11	18	25	2
Sunday	5	12	19	26	3
Week	44	45	46	47	48

23
Monday
Montag
Lundi
Lunes
Lunedì
Segunda-feira
Maandag
月曜日

24
Tuesday
Dienstag
Mardi
Martes
Martedì
Terça-feira
Dinsdag
火曜日

25
Wednesday
Mittwoch
Mercredi
Miércoles
Mercoledì
Quarta-feira
Woensdag
水曜日

26
Thursday
Donnerstag
Jeudi
Jueves
Giovedì
Quinta-feira
Donderdag
木曜日

Ⓐ Nationalfeiertag

27
Friday
Freitag
Vendredi
Viernes
Venerdì
Sexta-feira
Vrijdag
金曜日

28
Saturday
Samstag
Samedi
Sábado
Sabato
Sábado
Zaterdag
土曜日

29
Sunday
Sonntag
Dimanche
Domingo
Domenica
Domingo
Zondag
日曜日

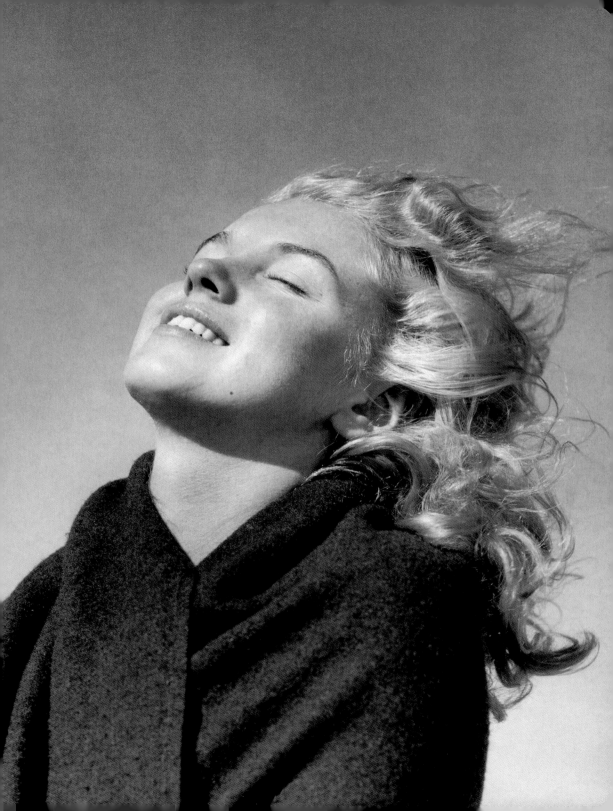

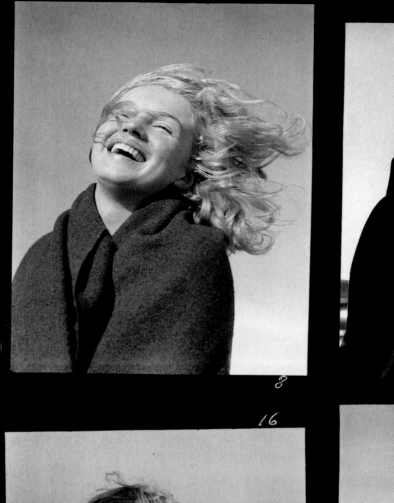

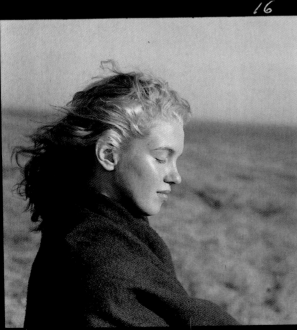
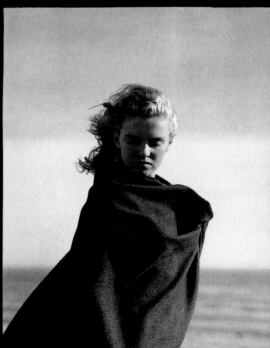

OCTOBER 2006						
Monday	25	2	9	16	23	30
Tuesday	26	3	10	17	24	31
Wednesday	27	4	11	18	25	1
Thursday	28	5	12	19	26	2
Friday	29	6	13	20	27	3
Saturday	30	7	14	21	28	4
Sunday	1	8	15	22	29	5
Week	39	40	41	42	43	44

NOVEMBER 2006					
Monday	30	6	13	20	27
Tuesday	31	7	14	21	28
Wednesday	1	8	15	22	29
Thursday	2	9	16	23	30
Friday	3	10	17	24	1
Saturday	4	11	18	25	2
Sunday	5	12	19	26	3
Week	44	45	46	47	48

DECEMBER 2006					
Monday	27	4	11	18	25
Tuesday	28	5	12	19	26
Wednesday	29	6	13	20	27
Thursday	30	7	14	21	28
Friday	1	8	15	22	29
Saturday	2	9	16	23	30
Sunday	3	10	17	24	31
Week	48	49	50	51	52

6
Monday
Montag
Lundi
Lunes
Lunedì
Segunda-feira
Maandag
月曜日

7
Tuesday
Dienstag
Mardi
Martes
Martedì
Terça-feira
Dinsdag
火曜日

8
Wednesday
Mittwoch
Mercredi
Miércoles
Mercoledì
Quarta-feira
Woensdag
水曜日

9
Thursday
Donnerstag
Jeudi
Jueves
Giovedì
Quinta-feira
Donderdag
木曜日

10
Friday
Freitag
Vendredi
Viernes
Venerdì
Sexta-feira
Vrijdag
金曜日

(USA) Veterans' Day

11
Saturday
Samstag
Samedi
Sábado
Sabato
Sábado
Zaterdag
土曜日

(CDN) Remembrance Day | Jour du Souvenir
(F) Armistice 1918

12
Sunday
Sonntag
Dimanche
Domingo
Domenica
Domingo
Zondag
日曜日

OCTOBER 2006						
Monday	25	2	9	16	23	30
Tuesday	26	3	10	17	24	31
Wednesday	27	4	11	18	25	1
Thursday	28	5	12	19	26	2
Friday	29	6	13	20	27	3
Saturday	30	7	14	21	28	4
Sunday	1	8	15	22	29	5
Week	39	40	41	42	43	44

NOVEMBER 2006					
Monday	30	6	13	20	27
Tuesday	31	7	14	21	28
Wednesday	1	8	15	22	29
Thursday	2	9	16	23	30
Friday	3	10	17	24	1
Saturday	4	11	18	25	2
Sunday	5	12	19	26	3
Week	44	45	46	47	48

DECEMBER 2006					
Monday	27	4	11	18	25
Tuesday	28	5	12	19	26
Wednesday	29	6	13	20	27
Thursday	30	7	14	21	28
Friday	1	8	15	22	29
Saturday	2	9	16	23	30
Sunday	3	10	17	24	31
Week	48	49	50	51	52

30
Monday
Montag
Lundi
Lunes
Lunedì
Segunda-feira
Maandag
月曜日

(IRL) Last Monday in October

31
Tuesday
Dienstag
Mardi
Martes
Martedì
Terça-feira
Dinsdag
火曜日

(D) Reformationstag (teilweise)

1
Wednesday
Mittwoch
Mercredi
Miércoles
Mercoledì
Quarta-feira
Woensdag
水曜日

(D) Allerheiligen (teilweise)

(F) (A) (E) (I) (P)
Toussaint | Allerheiligen | Todos los
Santos | Ognissanti | Todos os Santos

2
Thursday
Donnerstag
Jeudi
Jueves
Giovedì
Quinta-feira
Donderdag
木曜日

3
Friday
Freitag
Vendredi
Viernes
Venerdì
Sexta-feira
Vrijdag
金曜日

(J) Culture Day

4
Saturday
Samstag
Samedi
Sábado
Sabato
Sábado
Zaterdag
土曜日

5
○ Sunday
Sonntag
Dimanche
Domingo
Domenica
Domingo
Zondag
日曜日

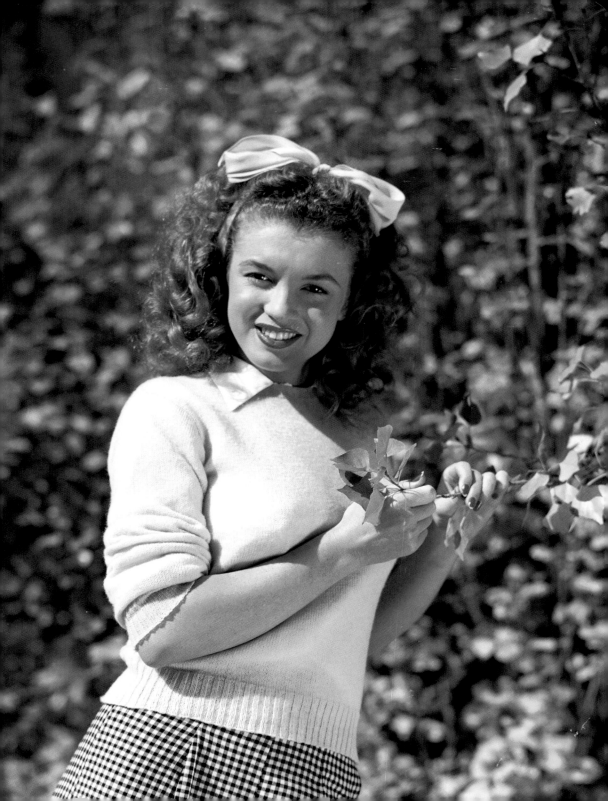

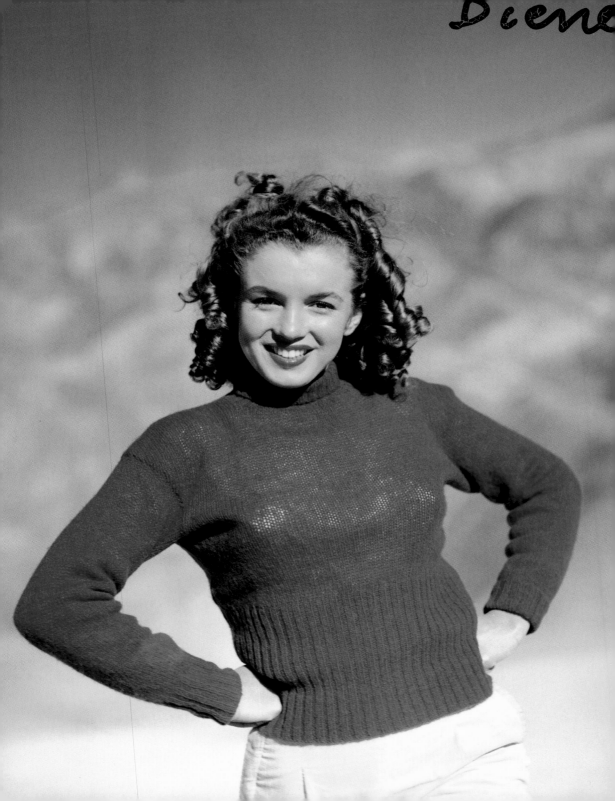

2006 NOVEMBER NOVEMBER NOVEMBRE NOVIEMBRE NOVEMBRE NOVEMBRO NOVEMBER 11月

OCTOBER 2006

Monday	25	2	9	16	23	30
Tuesday	26	3	10	17	24	31
Wednesday	27	4	11	18	25	1
Thursday	28	5	12	19	26	2
Friday	29	6	13	20	27	3
Saturday	30	7	14	21	28	4
Sunday	1	8	15	22	29	5
Week	39	40	41	42	43	44

NOVEMBER 2006

Monday	30	6	13	20	27
Tuesday	31	7	14	21	28
Wednesday	1	8	15	22	29
Thursday	2	9	16	23	30
Friday	3	10	17	24	1
Saturday	4	11	18	25	2
Sunday	5	12	19	26	3
Week	44	45	46	47	48

DECEMBER 2006

Monday	27	4	11	18	25
Tuesday	28	5	12	19	26
Wednesday	29	6	13	20	27
Thursday	30	7	14	21	28
Friday	1	8	15	22	29
Saturday	2	9	16	23	30
Sunday	3	10	17	24	31
Week	48	49	50	51	52

13
Monday
Montag
Lundi
Lunes
Lunedì
Segunda-feira
Maandag
月曜日

14
Tuesday
Dienstag
Mardi
Martes
Martedì
Terça-feira
Dinsdag
火曜日

15
Wednesday
Mittwoch
Mercredi
Miércoles
Mercoledì
Quarta-feira
Woensdag
水曜日

16
Thursday
Donnerstag
Jeudi
Jueves
Giovedì
Quinta-feira
Donderdag
木曜日

17
Friday
Freitag
Vendredi
Viernes
Venerdì
Sexta-feira
Vrijdag
金曜日

18
Saturday
Samstag
Samedi
Sábado
Sabato
Sábado
Zaterdag
土曜日

19
Sunday
Sonntag
Dimanche
Domingo
Domenica
Domingo
Zondag
日曜日

OCTOBER 2006

Monday	25	2	9	16	23	30
Tuesday	26	3	10	17	24	31
Wednesday	27	4	11	18	25	1
Thursday	28	5	12	19	26	2
Friday	29	6	13	20	27	3
Saturday	30	7	14	21	28	4
Sunday	1	8	15	22	29	5
Week	39	40	41	42	43	44

NOVEMBER 2006

Monday	30	6	13	20	27	
Tuesday	31	7	14	21	28	
Wednesday	1	8	15	22	29	
Thursday	2	9	16	23	30	
Friday	3	10	17	24	1	
Saturday	4	11	18	25	2	
Sunday	5	12	19	26	3	
Week	44	45	46	47	48	

DECEMBER 2006

Monday	27	4	11	18	25	
Tuesday	28	5	12	19	26	
Wednesday	29	6	13	20	27	
Thursday	30	7	14	21	28	
Friday	1	8	15	22	29	
Saturday	2	9	16	23	30	
Sunday	3	10	17	24	31	
Week	48	49	50	51	52	

20 ● Monday / Montag / Lundi / Lunes / Lunedì / Segunda-feira / Maandag / 月曜日

21 Tuesday / Dienstag / Mardi / Martes / Martedì / Terça-feira / Dinsdag / 火曜日

22 Wednesday / Mittwoch / Mercredi / Miércoles / Mercoledì / Quarta-feira / Woensdag / 水曜日

Ⓓ Buß- und Bettag (teilweise)

23 Thursday / Donnerstag / Jeudi / Jueves / Giovedì / Quinta-feira / Donderdag / 木曜日

ⓊⓈⒶ Thanksgiving Day

Ⓙ Labor-Thanksgiving Day

24 Friday / Freitag / Vendredi / Viernes / Venerdì / Sexta-feira / Vrijdag / 金曜日

25 Saturday / Samstag / Samedi / Sábado / Sabato / Sábado / Zaterdag / 土曜日

26 Sunday / Sonntag / Dimanche / Domingo / Domenica / Domingo / Zondag / 日曜日

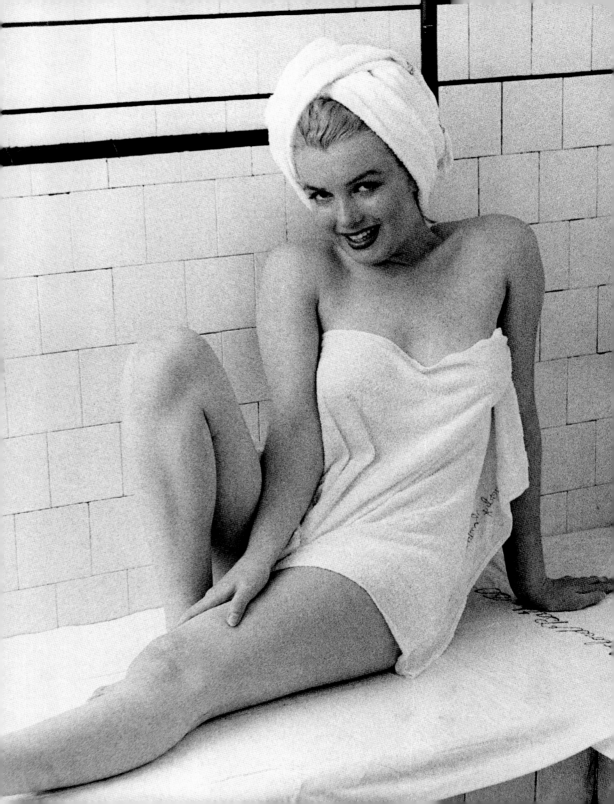

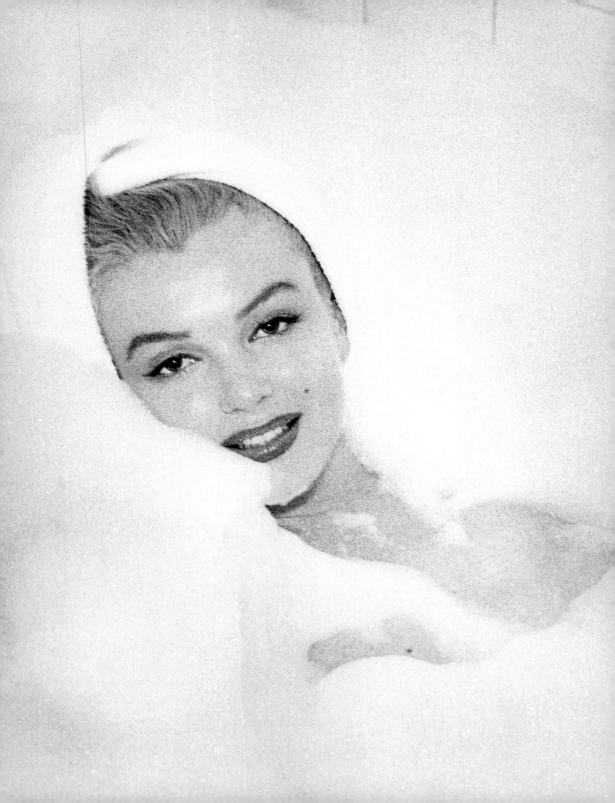

NOVEMBER 2006

Monday	30	6	13	20	27
Tuesday	31	7	14	21	28
Wednesday	1	8	15	22	29
Thursday	2	9	16	23	30
Friday	3	10	17	24	1
Saturday	4	11	18	25	2
Sunday	5	12	19	26	3
Week	44	45	46	47	48

DECEMBER 2006

Monday	27	4	11	18	25
Tuesday	28	5	12	19	26
Wednesday	29	6	13	20	27
Thursday	30	7	14	21	28
Friday	1	8	15	22	29
Saturday	2	9	16	23	30
Sunday	3	10	17	24	31
Week	48	49	50	51	52

JANUAR 2007

Monday	25	1	8	15	22	29
Tuesday	26	2	9	16	23	30
Wednesday	27	3	10	17	24	31
Thursday	28	4	11	18	25	1
Friday	29	5	12	19	26	2
Saturday	30	6	13	20	27	3
Sunday	31	7	14	21	28	4
Week	52	1	2	3	4	5

27
Monday
Montag
Lundi
Lunes
Lunedì
Segunda-feira
Maandag
月曜日

28
Tuesday
Dienstag
Mardi
Martes
Martedì
Terça-feira
Dinsdag
火曜日

29
Wednesday
Mittwoch
Mercredi
Miércoles
Mercoledì
Quarta-feira
Woensdag
水曜日

30
Thursday
Donnerstag
Jeudi
Jueves
Giovedì
Quinta-feira
Donderdag
木曜日

1
Friday
Freitag
Vendredi
Viernes
Venerdì
Sexta-feira
Vrijdag
金曜日

P Dia da Restauração

2
Saturday
Samstag
Samedi
Sábado
Sabato
Sábado
Zaterdag
土曜日

3
Sunday
Sonntag
Dimanche
Domingo
Domenica
Domingo
Zondag
日曜日

WEEK 48

2006 DECEMBER DEZEMBER DÉCEMBRE DICIEMBRE DICEMBRE DEZEMBRO DECEMBER 12月

NOVEMBER 2006					
Monday	30	6	13	20	27
Tuesday	31	7	14	21	28
Wednesday	1	8	15	22	29
Thursday	2	9	16	23	30
Friday	3	10	17	24	1
Saturday	4	11	18	25	2
Sunday	5	12	19	26	3
Week	44	45	46	47	48

DECEMBER 2006					
Monday	27	4	11	18	25
Tuesday	28	5	12	19	26
Wednesday	29	6	13	20	27
Thursday	30	7	14	21	28
Friday	1	8	15	22	29
Saturday	2	9	16	23	30
Sunday	3	10	17	24	31
Week	48	49	50	51	52

JANUAR 2007						
Monday	25	1	8	15	22	29
Tuesday	26	2	9	16	23	30
Wednesday	27	3	10	17	24	31
Thursday	28	4	11	18	25	1
Friday	29	5	12	19	26	2
Saturday	30	6	13	20	27	3
Sunday	31	7	14	21	28	4
Week	52	1	2	3	4	5

4
Monday
Montag
Lundi
Lunes
Lunedì
Segunda-feira
Maandag
月曜日

○ **5**
Tuesday
Dienstag
Mardi
Martes
Martedì
Terça-feira
Dinsdag
火曜日

6
Wednesday
Mittwoch
Mercredi
Miércoles
Mercoledì
Quarta-feira
Woensdag
水曜日

Ⓔ Día de la Constitución

7
Thursday
Donnerstag
Jeudi
Jueves
Giovedì
Quinta-feira
Donderdag
木曜日

8
Friday
Freitag
Vendredi
Viernes
Venerdì
Sexta-feira
Vrijdag
金曜日

Ⓐ Ⓔ Ⓘ Ⓟ
Mariä Empfängnis | Inmaculada
Concepción | Immacolata Concezione |
Imaculada Conceição

9
Saturday
Samstag
Samedi
Sábado
Sabato
Sábado
Zaterdag
土曜日

10
Sunday
Sonntag
Dimanche
Domingo
Domenica
Domingo
Zondag
日曜日

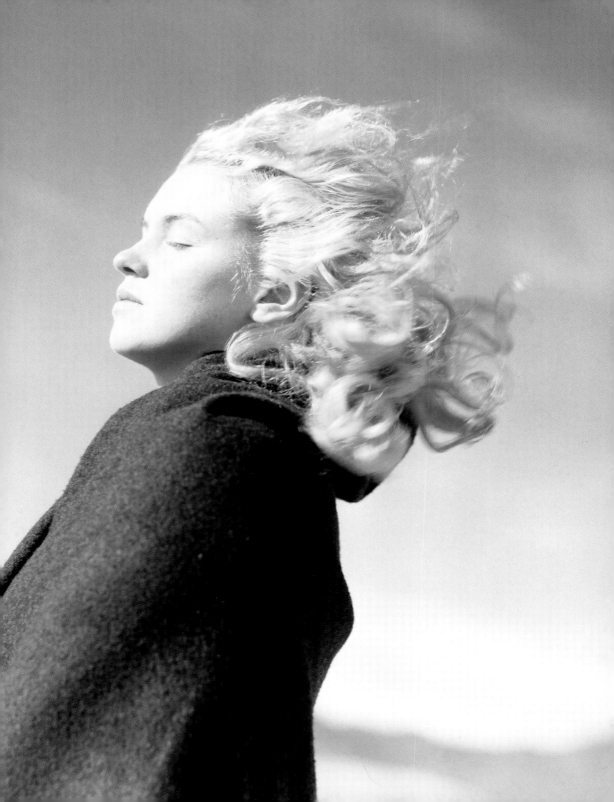

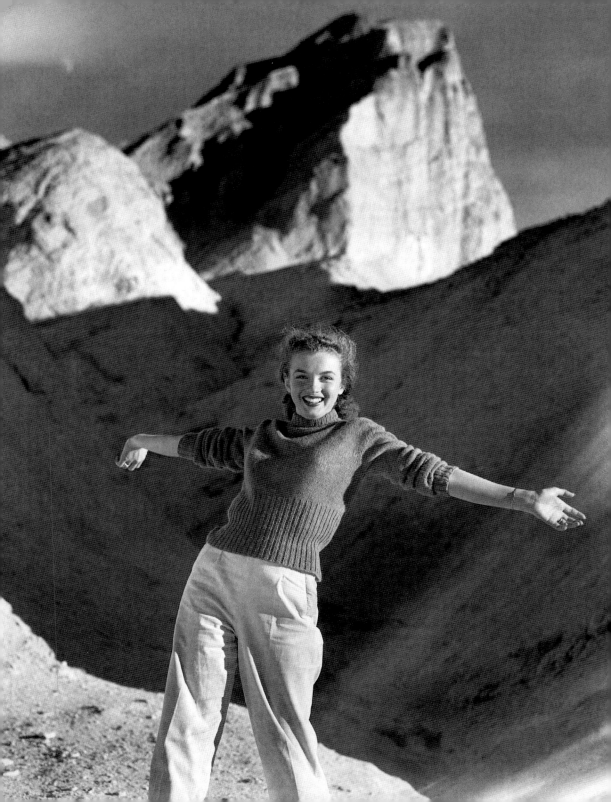

NOVEMBER 2006

Monday	30	6	13	20	27
Tuesday	31	7	14	21	28
Wednesday	1	8	15	22	29
Thursday	2	9	16	23	30
Friday	3	10	17	24	1
Saturday	4	11	18	25	2
Sunday	5	12	19	26	3
Week	44	45	46	47	48

DECEMBER 2006

Monday	27	4	11	18	25
Tuesday	28	5	12	19	26
Wednesday	29	6	13	20	27
Thursday	30	7	14	21	28
Friday	1	8	15	22	29
Saturday	2	9	16	23	30
Sunday	3	10	17	24	31
Week	48	49	50	51	52

JANUAR 2007

Monday	25	1	8	15	22	29
Tuesday	26	2	9	16	23	30
Wednesday	27	3	10	17	24	31
Thursday	28	4	11	18	25	1
Friday	29	5	12	19	26	2
Saturday	30	6	13	20	27	3
Sunday	31	7	14	21	28	4
Week	52	1	2	3	4	5

11
Monday
Montag
Lundi
Lunes
Lunedì
Segunda-feira
Maandag
月曜日

12
Tuesday
Dienstag
Mardi
Martes
Martedì
Terça-feira
Dinsdag
火曜日

13
Wednesday
Mittwoch
Mercredi
Miércoles
Mercoledì
Quarta-feira
Woensdag
水曜日

14
Thursday
Donnerstag
Jeudi
Jueves
Giovedì
Quinta-feira
Donderdag
木曜日

15
Friday
Freitag
Vendredi
Viernes
Venerdì
Sexta-feira
Vrijdag
金曜日

(IL) Hanukkah

16
Saturday
Samstag
Samedi
Sábado
Sabato
Sábado
Zaterdag
土曜日

17
Sunday
Sonntag
Dimanche
Domingo
Domenica
Domingo
Zondag
日曜日

WEEK 50

2006 DECEMBER DEZEMBER DÉCEMBRE DICIEMBRE DICEMBRE DEZEMBRO DECEMBER 12月

NOVEMBER 2006					
Monday	30	6	13	20	27
Tuesday	31	7	14	21	28
Wednesday	1	8	15	22	29
Thursday	2	9	16	23	30
Friday	3	10	17	24	1
Saturday	4	11	18	25	2
Sunday	5	12	19	26	3
Week	44	45	46	47	48

DECEMBER 2006					
Monday	27	4	11	18	25
Tuesday	28	5	12	19	26
Wednesday	29	6	13	20	27
Thursday	30	7	14	21	28
Friday	1	8	15	22	29
Saturday	2	9	16	23	30
Sunday	3	10	17	24	31
Week	48	49	50	51	52

JANUAR 2007						
Monday	25	1	8	15	22	29
Tuesday	26	2	9	16	23	30
Wednesday	27	3	10	17	24	31
Thursday	28	4	11	18	25	1
Friday	29	5	12	19	26	2
Saturday	30	6	13	20	27	3
Sunday	31	7	14	21	28	4
Week	52	1	2	3	4	5

18 Monday / Montag / Lundi / Lunes / Lunedì / Segunda-feira / Maandag / 月曜日

19 Tuesday / Dienstag / Mardi / Martes / Martedì / Terça-feira / Dinsdag / 火曜日

20 Wednesday / Mittwoch / Mercredi / Miércoles / Mercoledì / Quarta-feira / Woensdag / 水曜日

21 Thursday / Donnerstag / Jeudi / Jueves / Giovedì / Quinta-feira / Donderdag / 木曜日

22 Friday / Freitag / Vendredi / Viernes / Venerdì / Sexta-feira / Vrijdag / 金曜日

23 Saturday / Samstag / Samedi / Sábado / Sabato / Sábado / Zaterdag / 土曜日
(J) Emperor's Birthday

24 Sunday / Sonntag / Dimanche / Domingo / Domenica / Domingo / Zondag / 日曜日

WEEK 51

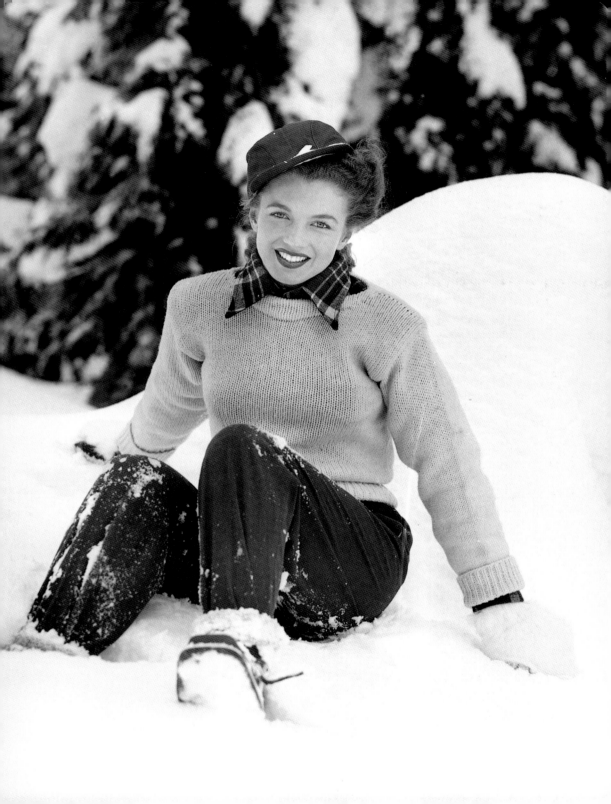

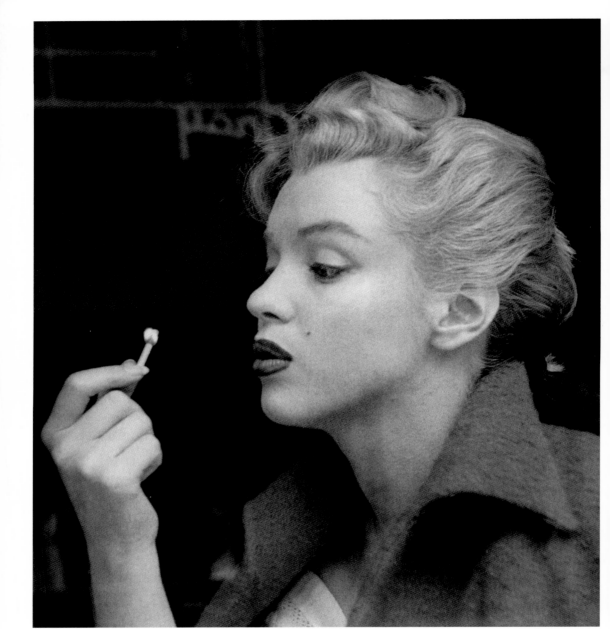

NOVEMBER 2006

Monday	30	6	13	20	27
Tuesday	31	7	14	21	28
Wednesday	1	8	15	22	29
Thursday	2	9	16	23	30
Friday	3	10	17	24	1
Saturday	4	11	18	25	2
Sunday	5	12	19	26	3
Week	44	45	46	47	48

DECEMBER 2006

Monday	27	4	11	18	25
Tuesday	28	5	12	19	26
Wednesday	29	6	13	20	27
Thursday	30	7	14	21	28
Friday	1	8	15	22	29
Saturday	2	9	16	23	30
Sunday	3	10	17	24	31
Week	48	49	50	51	52

JANUAR 2007

Monday	25	1	8	15	22	29
Tuesday	26	2	9	16	23	30
Wednesday	27	3	10	17	24	31
Thursday	28	4	11	18	25	1
Friday	29	5	12	19	26	2
Saturday	30	6	13	20	27	3
Sunday	31	7	14	21	28	4
Week	52	1	2	3	4	5

25 Monday / Montag / Lundi / Lunes / Lunedì / Segunda-feira / Maandag / 月曜日

(USA) (UK) (IRL) (ROK) (CDN) (F) (D) (A) (CH)
(NL) (E) (I) (P)

Christmas Day | Noël | 1. Weihnachtstag |
Weihnachten | 1º Kerstdag | Natividad
del Señor | Natale | Dia de Natal

26 Tuesday / Dienstag / Mardi / Martes / Martedì / Terça-feira / Dinsdag / 火曜日

(UK) (IRL) (CDN) (D) (A) (CH) (NL) (I)

Boxing Day | Saint Stephen's Day |
Lendemain de Noël | 2. Weihnachtstag |
Stefanstag | S. Etienne | 2º Kerstdag |
S. Stefano

27 Wednesday / Mittwoch / Mercredi / Miércoles / Mercoledì / Quarta-feira / Woensdag / 水曜日

28 Thursday / Donnerstag / Jeudi / Jueves / Giovedì / Quinta-feira / Donderdag / 木曜日

29 Friday / Freitag / Vendredi / Viernes / Venerdì / Sexta-feira / Vrijdag / 金曜日

30 Saturday / Samstag / Samedi / Sábado / Sabato / Sábado / Zaterdag / 土曜日

31 Sunday / Sonntag / Dimanche / Domingo / Domenica / Domingo / Zondag / 日曜日

PUBLIC HOLIDAYS 2006

(A) Österreich
- 1.1 Neujahr
- 6.1 Heilige Drei Könige
- 16.4 Ostersonntag
- 17.4 Ostermontag
- 1.5 Maifeiertag
- 25.5 Christi Himmelfahrt
- 4.6 Pfingstsonntag
- 5.6 Pfingstmontag
- 15.6 Fronleichnam
- 15.8 Mariä Himmelfahrt
- 26.10 Nationalfeiertag
- 1.11 Allerheiligen
- 8.12 Mariä Empfängnis
- 25.12 1. Weihnachtstag
- 26.12 2. Weihnachtstag

(AUS) Australia
- 2.1 New Year's Day
- 26.1 Australia Day
- 14.4 Good Friday
- 16.4 Easter Sunday
- 17.4 Easter Monday
- 25.4 Anzac Day
- 12.6 Queen's Birthday
- 2.10 Labour Day
- 25.12 Christmas Day
- 26.12 Boxing Day

(B) Belgique | België
- 1.1 Jour de l'An | Nieuwjaar
- 16.4 Pâques | Pasen
- 17.4 Lundi de Pâques | Paasmaandag
- 1.5 Fête du Travail | Feest van de Arbeid
- 25.5 Ascension | Onze-Lieve-Heer-Hemelvaart
- 4.6 Pentecôte | Pinksteren
- 5.6 Lundi de Pentecôte | Pinkstermaandag
- 21.7 Fête nationale | Nationale Feestdag
- 15.8 Assomption | Onze-Lieve-Vrouw-Hemelvaart
- 1.11 Toussaint | Allerheiligen
- 11.11 Armistice | Wapenstilstand
- 25.12 Noël | Kerstmis

(BR) Brasil
- 1.1 Ano Novo
- 28.2 Carnaval
- 14.4 Sexta-feira da Paixão
- 16.4 Páscoa
- 21.4 Tiradentes
- 1.5 Dia do Trabalho
- 15.6 Corpus Christi
- 7.9 Independência do Brasil
- 12.10 Nossa Senhora Aparecida
- 2.11 Finados
- 15.11 Proclamação da República
- 25.12 Natal

(CDN) Canada
- 1.1 New Year's Day | Jour de l'An
- 14.4 Good Friday | Vendredi Saint
- 16.4 Easter Sunday | Pâques
- 17.4 Easter Monday | Lundi de Pâques
- 22.5 Victoria Day | Fête de la Reine
- 1.7 Canada Day | Fête du Canada
- 4.9 Labour Day | Fête du Travail
- 9.10 Thanksgiving Day | Action de Grâces
- 11.11 Remembrance Day | Jour du Souvenir
- 25.12 Christmas Day | Noël
- 26.12 Boxing Day | Lendemain de Noël

(CH) Schweiz | Suisse | Svizzera
- 1.1 Neujahr | Nouvel An | Capodanno
- 14.4 Karfreitag | Vendredi Saint | Venerdì Santo
- 16.4 Ostern | Pâques | Pasqua
- 17.4 Ostermontag | Lundi de Pâques | Lunedì dell'Angelo
- 25.5 Auffahrt | Ascension | Ascensione
- 4.6 Pfingstsonntag | Pentecôte | Pentecoste
- 5.6 Pfingstmontag | Lundi de Pentecôte | Lunedì di Pentecoste
- 1.8 Bundesfeiertag | Fête nationale | Festa nazionale
- 25.12 Weihnachten | Noël | Natale
- 26.12 Stefanstag | S. Etienne | S. Stefano

(CO) Colombia
- 1.1 Año Nuevo
- 9.1 Reyes Magos
- 20.3 San José
- 13.4 Jueves Santo
- 14.4 Viernes Santo
- 16.4 Pascua
- 1.5 Día del Trabajo
- 29.5 Ascención del Señor
- 19.6 Corpus Christi
- 26.6 Sagrado Corazón
- 3.7 San Pedro y San Pablo
- 20.7 Independencia Nacional
- 7.8 Batalla de Boyacá
- 21.8 Asunción de la Virgen
- 16.10 Día de la Raza
- 6.11 Día de Todos los Santos
- 13.11 Independencia de Cartagena

- 8.12 Inmaculada Concepción
- 25.12 Navidad

(D) Bundesrepublik Deutschland
- 1.1 Neujahr
- 6.1 Heilige Drei Könige (teilw.)
- 14.4 Karfreitag
- 16.4 Ostersonntag
- 17.4 Ostermontag
- 1.5 Maifeiertag
- 25.5 Christi Himmelfahrt
- 4.6 Pfingstsonntag
- 5.6 Pfingstmontag
- 15.6 Fronleichnam (teilw.)
- 15.8 Mariä Himmelfahrt (teilw.)
- 3.10 Tag der Deutschen Einheit
- 31.10 Reformationstag (teilw.)
- 1.11 Allerheiligen (teilw.)
- 22.11 Buß- und Bettag (teilw.)
- 25.12 1. Weihnachtstag
- 26.12 2. Weihnachtstag

(DK) Danmark
- 1.1 Nytår
- 13.4 Skærtorsdag
- 14.4 Langfredag
- 16.4 Påske
- 17.4 Påske
- 12.5 St. Bededag
- 25.5 Kristi himmelfartsdag
- 4.6 Pinse
- 5.6 2. Pinsedag
- 5.6 Grundlovsdag
- 25.12 Juledag
- 26.12 St. Stefansdag

(E) España | Catalunya
- 1.1 Año Nuevo | Cap d'Any
- 6.1 Reyes | Reis
- 14.4 Viernes Santo | Divendres Sant
- 16.4 Pascua | Diumenge de Pascua
- 1.5 Fiesta del Trabajo | Festa del Treball
- 15.8 Asunción de la Virgen | L'Assumpció
- 12.10 Fiesta Nacional | Festa Nacional d'Espanya
- 1.11 Todos los Santos | Tots Sants
- 6.12 Día de la Constitución | Dia de la Constitució
- 8.12 Inmaculada Concepción | La Immaculada
- 25.12 Natividad del Señor | Nadal

(F) France
- 1.1 Jour de l'An
- 16.4 Pâques
- 17.4 Lundi de Pâques

- 1.5 Fête du Travail
- 8.5 Fête de la Libération
- 25.5 Ascension
- 4.6 Pentecôte
- 5.6 Lundi de Pentecôte
- 14.7 Fête Nationale
- 15.8 Assomption
- 1.11 Toussaint
- 11.11 Armistice 1918
- 25.12 Noël

(FIN) Suomi
- 1.1 Uudenvuodenpäivä
- 6.1 Loppiainen
- 14.4 Pitkäperjantai
- 16.4 Pääsiäispäivä
- 17.4 2. Pääsiäispäivä
- 1.5 Vapunpäivä
- 25.5 Helatorstai
- 4.6 Helluntaipäivä
- 25.6 Juhannuspäivä
- 4.11 Pyhäinpäivä
- 6.12 Itsenäisyyspäivä
- 25.12 Joulupäivä
- 26.12 Tapaninpäivä

(I) Italia
- 1.1 Capodanno
- 6.1 Epifania
- 16.4 Pasqua
- 17.4 Lunedì dell' Angelo
- 25.4 Liberazione
- 1.5 Festa del Lavoro
- 2.6 Festa della Repubblica
- 15.8 Assunzione
- 1.11 Ognissanti
- 8.12 Immacolata Concezione
- 25.12 Natale
- 26.12 S. Stefano

(IL) Israel
- 2.1 Hanukkah
- 13.2 Tu B'Shevat
- 14.3 Purim
- 13.4 Passover
- 19.4 Passover
- 25.4 Yom Hashoah
- 3.5 Yom Haatzmaut
- 2.6 Shavuot
- 3.8 Tisha B'Av
- 23.9 Rosh Hashanah
- 24.9 Rosh Hashanah
- 2.10 Yom Kippur
- 7.10 Succoth
- 14.10 Sh'mini Atzereth
- 14.10 Simchat Torah
- 15.12 Hanukkah

(IRL) Ireland
- 1.1 New Year's Day

PUBLIC HOLIDAYS 2006

2.1 Public Holiday
17.3 Saint Patrick's Day
16.4 Easter Sunday
17.4 Easter Monday
1.5 First Monday in May
5.6 First Monday in June
7.8 First Monday in August
30.10 Last Monday in October
25.12 Christmas Day
26.12 Saint Stephen's Day

(J) Japan
1.1 New Year's Day
2.1 Public Holiday
9.1 Coming-of-Age Day
11.2 Commemoration of the
Founding of the Nation
21.3 Vernal Equinox Day
29.4 Greenery Day
3.5 Constitution Day
4.5 Public Holiday
5.5 Children's Day
17.7 Marine Day
18.9 Respect-for-the-Aged Day
23.9 Autumn Equinox Day
9.10 Health-Sports Day
3.11 Culture Day
23.11 Labor-Thanksgiving Day
23.12 Emperor's Birthday

(L) Luxembourg
1.1 Jour de l'An
27.2 Lundi de Carnaval
16.4 Pâques
17.4 Lundi de Pâques
1.5 Fête du Travail
25.5 Ascension
4.6 Pentecôte
5.6 Lundi de Pentecôte
23.6 Fête Nationale
15.8 Assomption
1.11 Toussaint
25.12 Noël
26.12 Lendemain de Noël

(MEX) México
1.1 Año Nuevo
5.2 Aniversario de la Constitución
21.3 Natalicio de Benito Juárez
13.4 Jueves Santo
14.4 Viernes Santo
16.4 Pascua
1.5 Día del Trabajo
1.9 Informe presidencial
16.9 Día de la Independencia
20.11 Aniversario de la
Revolución Mexicana
25.12 Navidad

(N) Norge
1.1 Nyttårsdag
9.4 Palmesøndag
13.4 Skjærtorsdag
14.4 Langfredag
16.4 1. påskedag
17.4 2. påskedag
1.5 Offentlig høytidsdag
17.5 Grunnlovsdag
25.5 Kristi himmelfartsdag
4.6 1. pinsedag
5.6 2. pinsedag
25.12 1. juledag
26.12 2. juledag

(NL) Nederland
1.1 Nieuwjaarsdag
16.4 1e Paasdag
17.4 2e Paasdag
30.4 Koninginnedag
25.5 Hemelvaartsdag
4.6 1e Pinksterdag
5.6 2e Pinksterdag
25.12 1e Kerstdag
26.12 2e Kerstdag

(NZ) New Zealand
1.1 New Year's Day
2.1 Public Holiday
6.2 Waitangi Day
14.4 Good Friday
16.4 Easter Sunday
17.4 Easter Monday
25.4 Anzac Day
5.6 Queen's Birthday
30.10 Labour Day
25.12 Christmas Day
26.12 Boxing Day

(P) Portugal
1.1 Ano Novo
28.2 Terça-feira de Carnaval
25.3 Sexta-feira Santa
27.3 Domingo de Páscoa
25.4 Dia da Liberdade
1.5 Dia do Trabalho
10.6 Dia Nacional
15.6 Corpo de Deus
15.8 Assunção de Nossa Senhora
5.10 Implantação da República
1.11 Todos os Santos
1.12 Dia da Restauração
8.12 Imaculada Conceição
25.12 Dia de Natal

(RA) Argentina
1.1 Año Nuevo
3.4 Recuperación de
las Islas Malvinas

13.4 Jueves Santo
14.4 Viernes Santo
16.4 Pascua
1.5 Día del Trabajador
25.5 Fundación del Primer
Gobierno Nacional
19.6 Día de la Bandera
9.7 Día de la Independencia
21.8 Muerte del General San
Martín
12.10 Descubrimiento de América
8.12 Inmaculada Concepción de
la Virgen María
25.12 Navidad

(RCH) Chile
1.1 Año Nuevo
14.4 Viernes Santo
16.4 Pascua
1.5 Día del Trabajo
21.5 Combate Naval de Iquique
12.6 Corpus Christi
29.6 San Pedro y San Pablo
15.8 Asunción de la Virgen
18.9 Fiestas Patrias
19.9 Día del Ejército
12.10 Día de la Hispanidad
1.11 Todos los Santos
8.12 Inmaculada Concepción
25.12 Navidad

(ROK) Korea
1.1 New Year's Day
1.3 Independence Movement
Day
5.4 Arbor Day
5.5 Children's Day
5.5 Buddha's Birthday
6.6 Memorial Day
17.7 Constitution Day
15.8 Independence Day
3.10 National Foundation Day
7.10 Chuseok
25.12 Christmas Day

(S) Sverige
1.1 Nyårsdagen
6.1 Trettondedag jul
14.4 Långfredagen
16.4 Påskdagen
17.4 Annandag påsk
1.5 Första maj
25.5 Kristi himmelsfärds dag
4.6 Pingstdagen
5.6 Annandag pingst
24.6 Midsommardagen
4.11 Alla helgons dag
25.12 Juldagen
26.12 Annandag jul

(UK) United Kingdom
1.1 New Year's Day
2.1 Public Holiday
3.1 Public Holiday
(Scotland only)
17.3 Saint Patrick's Day
(Northern Ireland only)
14.4 Good Friday
16.4 Easter Sunday
17.4 Easter Monday
(except Scotland)
1.5 Early May Bank Holiday
29.5 Spring Bank Holiday
12.7 Battle of the Boyne Day
(Northern Ireland only)
7.8 Summer Bank Holiday
(Scotland only)
28.8 Summer Bank Holiday
(except Scotland)
25.12 Christmas Day
26.12 Boxing Day

(USA) United States
1.1 New Year's Day
2.1 Public Holiday
16.1 Martin Luther King Day
20.2 President's Day
16.4 Easter Sunday
29.5 Memorial Day
4.7 Independence Day
4.9 Labor Day
9.10 Columbus Day
10.11 Veterans' Day
23.11 Thanksgiving Day
25.12 Christmas Day

(ZA) South Africa
1.1 New Year's Day
2.1 Public Holiday
21.3 Human Rights Day
14.4 Good Friday
16.4 Easter Sunday
17.4 Family Day
27.4 Freedom Day
1.5 Workers' Day
16.6 Youth Day
9.8 National Women's Day
25.9 Heritage Day
16.12 Day of Reconciliation
25.12 Christmas Day
26.12 Day of Goodwill

**Some international holidays may
be subject to change.**

01–04.2007

JANUARY	FEBRUARY	MARCH	APRIL
WEEK 1	1 Th	1 Th	1 Su
1 Mo	2 Fr ○	2 Fr	**WEEK 14**
2 Tu	3 Sa	3 Sa ○	2 Mo ○
3 We ○	4 Su	4 Su	3 Tu
4 Th	**WEEK 6**	**WEEK 10**	4 We
5 Fr	5 Mo	5 Mo	5 Th
6 Sa	6 Tu	6 Tu	6 Fr
7 Su	7 We	7 We	7 Sa
WEEK 2	8 Th	8 Th	8 Su
8 Mo	9 Fr	9 Fr	**WEEK 15**
9 Tu	10 Sa ◑	10 Sa	9 Mo
10 We	11 Su	11 Su	10 Tu ◑
11 Th ◑	**WEEK 7**	**WEEK 11**	11 We
12 Fr	12 Mo	12 Mo ◑	12 Th
13 Sa	13 Tu	13 Tu	13 Fr
14 Su	14 We	14 We	14 Sa
WEEK 3	15 Th	15 Th	15 Su
15 Mo	16 Fr	16 Fr	**WEEK 16**
16 Tu	17 Sa ●	17 Sa	16 Mo
17 We	18 Su	18 Su	17 Tu ●
18 Th	**WEEK 8**	**WEEK 12**	18 We
19 Fr ●	19 Mo	19 Mo ●	19 Th
20 Sa	20 Tu	20 Tu	20 Fr
21 Su	21 We	21 We	21 Sa
WEEK 4	22 Th	22 Th	22 Su
22 Mo	23 Fr	23 Fr	**WEEK 17**
23 Tu	24 Sa ◐	24 Sa	23 Mo
24 We	25 Su	25 Su ◐	24 Tu ◐
25 Th ◐	**WEEK 9**	**WEEK 13**	25 We
26 Fr	26 Mo	26 Mo	26 Th
27 Sa	27 Tu	27 Tu	27 Fr
28 Su	28 We	28 We	28 Sa
WEEK 5		29 Th	29 Su
29 Mo		30 Fr	**WEEK 18**
30 Tu		31 Sa	30 Mo
31 We			

05–08.2007

MAY

1 Tu
2 We ○
3 Th
4 Fr
5 Sa
6 Su

WEEK 19

7 Mo
8 Tu
9 We
10 Th ◗
11 Fr
12 Sa
13 Su

WEEK 20

14 Mo
15 Tu
16 We ●
17 Th
18 Fr
19 Sa
20 Su

WEEK 21

21 Mo
22 Tu
23 We ◖
24 Th
25 Fr
26 Sa
27 Su

WEEK 22

28 Mo
29 Tu
30 We
31 Th

JUNE

1 Fr ○
2 Sa
3 Su

WEEK 23

4 Mo
5 Tu
6 We
7 Th
8 Fr ◗
9 Sa
10 Su

WEEK 24

11 Mo
12 Tu
13 We
14 Th
15 Fr ●
16 Sa
17 Su

WEEK 25

18 Mo
19 Tu
20 We
21 Th
22 Fr ◖
23 Sa
24 Su

WEEK 26

25 Mo
26 Tu
27 We
28 Th
29 Fr
30 Sa ○

JULY

1 Su

WEEK 27

2 Mo
3 Tu
4 We
5 Th
6 Fr
7 Sa ◗
8 Su

WEEK 28

9 Mo
10 Tu
11 We
12 Th
13 Fr
14 Sa ●
15 Su

WEEK 29

16 Mo
17 Tu
18 We
19 Th
20 Fr
21 Sa
22 Su ◖

WEEK 30

23 Mo
24 Tu
25 We
26 Th
27 Fr
28 Sa
29 Su

WEEK 31

30 Mo ○
31 Tu

AUGUST

1 We
2 Th
3 Fr
4 Sa
5 Su ◗

WEEK 32

6 Mo
7 Tu
8 We
9 Th
10 Fr
11 Sa
12 Su ●

WEEK 33

13 Mo
14 Tu
15 We
16 Th
17 Fr
18 Sa
19 Su

WEEK 34

20 Mo ◖
21 Tu
22 We
23 Th
24 Fr
25 Sa
26 Su

WEEK 35

27 Mo
28 Tu ○
29 We
30 Th
31 Fr

SEPTEMBER

1 Sa	
2 Su	
WEEK 36	
3 Mo	
4 Tu ◗	
5 We	
6 Th	
7 Fr	
8 Sa	
9 Su	
WEEK 37	
10 Mo	
11 Tu ●	
12 We	
13 Th	
14 Fr	
15 Sa	
16 Su	
WEEK 38	
17 Mo	
18 Tu	
19 We ◖	
20 Th	
21 Fr	
22 Sa	
23 Su	
WEEK 39	
24 Mo	
25 Tu	
26 We ○	
27 Th	
28 Fr	
29 Sa	
30 Su	

OCTOBER

WEEK 40	
1 Mo	
2 Tu	
3 We ◗	
4 Th	
5 Fr	
6 Sa	
7 Su	
WEEK 41	
8 Mo	
9 Tu	
10 We	
11 Th ●	
12 Fr	
13 Sa	
14 Su	
WEEK 42	
15 Mo	
16 Tu	
17 We	
18 Th	
19 Fr ◖	
20 Sa	
21 Su	
WEEK 43	
22 Mo	
23 Tu	
24 We	
25 Th	
26 Fr ○	
27 Sa	
28 Su	
WEEK 44	
29 Mo	
30 Tu	
31 We	

NOVEMBER

1 Th ◗	
2 Fr	
3 Sa	
4 Su	
WEEK 45	
5 Mo	
6 Tu	
7 We	
8 Th	
9 Fr ●	
10 Sa	
11 Su	
WEEK 46	
12 Mo	
13 Tu	
14 We	
15 Th	
16 Fr	
17 Sa ◖	
18 Su	
WEEK 47	
19 Mo	
20 Tu	
21 We	
22 Th	
23 Fr	
24 Sa ○	
25 Su	
WEEK 48	
26 Mo	
27 Tu	
28 We	
29 Th	
30 Fr	

DECEMBER

1 Sa ◗	
2 Su	
WEEK 49	
3 Mo	
4 Tu	
5 We	
6 Th	
7 Fr	
8 Sa	
9 Su ●	
WEEK 50	
10 Mo	
11 Tu	
12 We	
13 Th	
14 Fr	
15 Sa	
16 Su	
WEEK 51	
17 Mo ◖	
18 Tu	
19 We	
20 Th	
21 Fr	
22 Sa	
23 Su	
WEEK 52	
24 Mo ○	
25 Tu	
26 We	
27 Th	
28 Fr	
29 Sa	
30 Su	
WEEK 1	
31 Mo ◗	

ADDRESSES AND NOTES

ADDRESSES AND NOTES

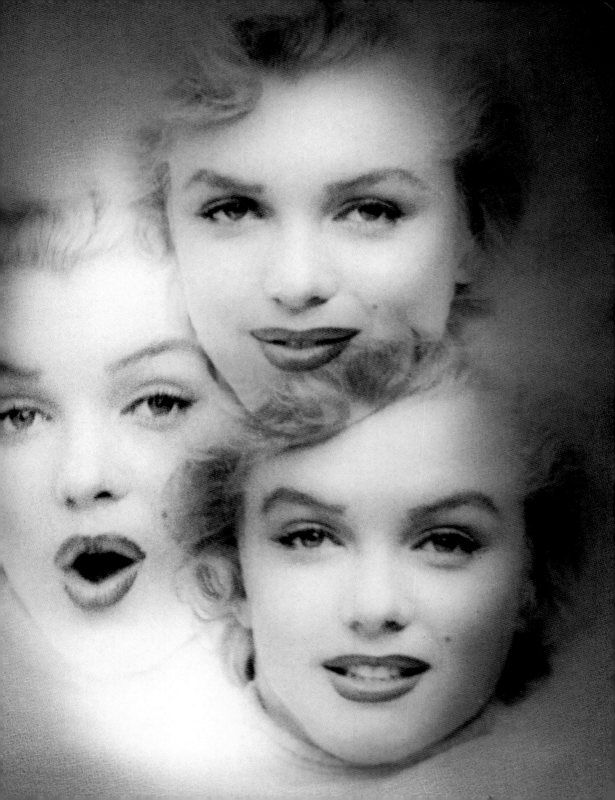

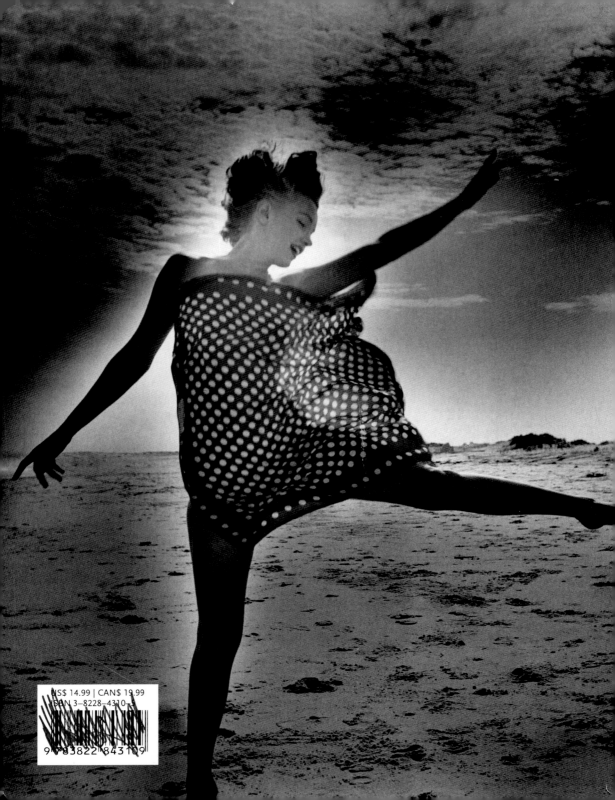

US$ 14.99 | CAN$ 19.99
ISBN 3-8228-4310-5